THE PORTRAIT BOOK

A Guide for Photographers

Steven H. Begleiter

AMHERST MEDIA, INC. ■ BUFFALO, NY

Dedicated to my son Makhesh, my wife Kate,
my niece Ali, and my nephews Derek and Michael.

ACKNOWLEDGMENTS

Thanks Kate.

Thank you to all the people who volunteered their time and faces in putting this project together. Thanks also to my Fairmount neighbors who volunteered to be photographed at the spur of the moment, no questions asked!

I would also like to thank the visual editors whose interviews appear in this book for taking time out of their busy schedules to share their insights.

This book could not have come together without the help of so many friends and artists:

Janette McVey, Ali Tepper, and Julia Granacki, for working behind the scenes.

Alan Friedlander of Rhom and Haas for providing needed hardware and space for illustrations.

Suzy Martin of Shooting Star Agency, who managed to track down and send back my celebrity archive.

The University of Pennsylvania's School of Design students who always remind me that it is one skill to take portraits and another to explain how it's done.

Finally, thanks to my publisher, Craig Alesse, at Amherst Media for giving me this opportunity, and my editor, Michelle Perkins, for her great editing and design skills—and for answering all of my phone calls.

Published by:
Amherst Media, Inc.
P.O. Box 586
Buffalo, N.Y. 14226
Fax: 716-874-4508
www.AmherstMedia.com

Publisher: Craig Alesse
Senior Editor/Production Manager: Michelle Perkins
Assistant Editor: Barbara A. Lynch-Johnt

ISBN: 1-58428-112-X
Library of Congress Card Catalog Number: 2003103024

Printed in Korea.
10 9 8 7 6 5 4 3 2 1

Front Cover: I created this portrait of cellist Stephanie Winters for my portfolio. I applied the technique of cross-processing to alter the color palette for a more dramatic look. (Camera—Mamiya RZ67 Pro; Lens—110mm; Film—Kodak VHC; Processing—in E chemistry; Lighting—strobe)

TABLE OF CONTENTS

About the Author

Steven H. Begleiter's critically acclaimed collection of portraits *Fathers and Sons* (Abbeville Press, 1989) was one of the first in the trend of "photographic relationship" books. His second book, *The Art of Color Infrared Photography* (Amherst Media, 2001) is the first book published on the creative application of color infrared photography. His images have appeared in over one hundred publications including *Time, Esquire, Forbes*, and *People Magazine*. He is a professional photographer and currently teaches part-time in the School of Design at the University of Pennsylvania. He lives in Philadelphia, PA, with his wife Kate, son Makhesh, and dog Winston. Additional images can be viewed by visiting his website at: www.begleiter.com.

INTRODUCTION

*a*S A PROFESSIONAL PHOTOGRAPHER WHO specializes in portraiture, my assignments over the last twenty years have taken me around the country to photograph celebrities, artists, scientists, CEOs, U.S. presidents, and "regular" folks. I have a passion for portrait photography because I have a passionate curiosity about people. Making a personal connection with my subjects has led to my most satisfying and artistically successful sessions. Depending on the logistics of a shoot, I may have several days or only a brief moment while adjusting my lighting to gain enough insight to inform my portrait. Through the years, I have learned a great deal about human nature. I have also learned a great deal about myself. I feel that it is both a privilege and a responsibility to be invited to create an image that will represent someone to the world. It is an art and a science. In this book I will address both of these aspects and explore how they are balanced in a successful portrait.

I was introduced to professional portrait photography through working as a photo assistant. After a year as a freelance news photographer in New York City, I landed a full-time assisting job with a commercial photographer who specialized in portraiture. This year of learning the day-to-day business was invaluable. Setting up the studio, casting models, dealing with clients, maintaining the equipment, and processing and printing work prints (in the pre-digital years) enabled me to hone my craft and learn the business side of the studio.

After a year of concentrated studio work, the opportunity presented itself to strike out in a new direction. A friend called and asked if I would like to take over his job as assistant to Annie Leibovitz. Without hesitation I said, "Yes!" and flew to New Mexico, where Annie

was on assignment for *Vanity Fair* photographing Debra Winger. For the next year I flew around the country with Annie photographing celebrities, traveling with eight or more cases of photography equipment. The pressure of producing consistently great results, often under less than ideal circumstances, was hard work and stressful to say the least. However, I can honestly say it was a great experience.

I then returned to New York City and resumed working as a freelance photo assistant. Over the next year, I was fortunate to work with other great people/portrait photographers such as Mary Ellen Mark, Michael O'Brien, and Abe Frajndlich.

After four years of assisting and starting to work on my own portrait projects, it was time to start my own business. That was twenty years ago.

▶ **ABOUT THIS BOOK**

My objective in writing this book was to create the type of resource I wish I'd had when I began my career in portrait photography. Whether you are a professional photographer or serious amateur, I hope this book will serve as an inspiration in the on-going process of developing your personal style. I will start with the basics. For some of you this will be review, for others it will add to your repertoire, and for some it will be the jumping off point. It covers the elements that are essential to fully expressing your artistic vision. These include the following:

Gaining an Historic Perspective. Studying the work of other photographers can provide fertile ground for your own visual expression. For example, William Coupon creates his striking images by using the same mottled background and shooting simple and tight images of his subjects. Phil Borges applies selective handcoloring to his sepia-toned black & white prints. Chip Simmons uses colored gels over his flash to create his unique world of color portraits.

Becoming Familiar with the Tools of the Trade. As with any medium, mastering the tools of the trade frees the artist to create. I will discuss equipment and lighting options, environment, and developing your personal "bag of tricks."

Purchasing the most expensive equipment does not guarantee a good portrait; in fact it can work against you. If you are intimidated by using a camera with all the bells and whistles, use a camera that is comfortable for you. I have seen great portraits taken with Brownie cameras. The photographer, not the camera, creates a good portrait.

The images throughout the book will be accompanied by technical descriptions and lighting diagrams, if applicable. If you are a beginner, these may be difficult to understand at first, but be patient. The technical information will be addressed in later chapters.

Balancing Art and Science to Capture your Personal Vision. In putting the elements together I will cover the actual portrait session; choosing the setting, creating the atmosphere, posing, wardrobe and make-up, and talking to your subject. In chapter 14 I will deal with the actual marketplace, including interviews I conducted with three top photo editors discussing various aspects of the business.

UNIQUE PHOTOGRAPHIC IMAGES ARISE FROM PERSONAL inspiration informed by both current photographic trends and a knowledge of the many styles that have shaped photography over time. Emulating the style(s) of your favorite portrait photographer(s) is both a form of flattery and a great learning experience.

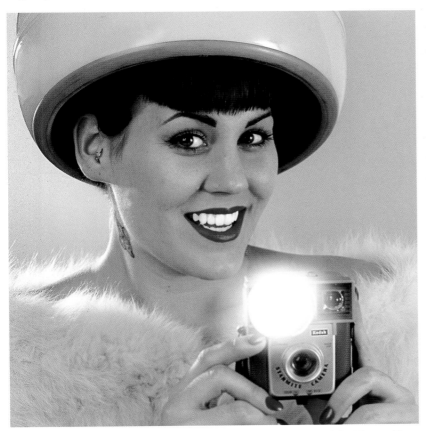

Here's an example of mixing the old with the new. I lit this model with a softbox to her left and a reflector to her right. A kicker light accented her neck and the fur wrap. After scanning the image, I used Adobe® Photoshop® to create the glow on the flash. (Camera—Hasselblad; Lens—120mm; Film—Kodak EPP)

Successful portrait photographers, like other artists, often turn to "the greats" for inspiration. They can study the elements of the work they find most compelling and, accessing available photo technology, apply their own style with a strong point of view. The end result is a new form, an image that is unique but that echoes the voices of the past.

It is beyond the scope of this book to discuss all of the many great portrait photographers who have played a part in the development of the artform throughout history. Instead, I have chosen as examples three individuals who have been both commercially successful and who created a unique style of portraiture that influenced their peers: Julia Margaret Cameron (b.1815-1879), Arnold Newman (b.1918), and Annie Leibovitz (b.1949).

▼ JULIA MARGARET CAMERON

Julia Margaret Cameron began taking portraits in 1863; only twenty-four years after Joseph Nicéphor Niépce, Louis Jacques Mandé Daguerre, and William Henry Fox Talbot introduced the public to the invention of photography.

Cameron was forty-eight when she began her career as a portrait photographer. While her husband was away on an extended trip, her daughter gave her a camera to cheer her up. As she was not trained as a portrait photographer, she was not bound by the conventions of her time. That freedom, and her excitement about photographing her friends and family, created a wonderful environment for creativity.

Her concern was not to create an exact likeness of her models for posterity, but rather to create an image that expressed the emotional state of her subjects. While most photographers of her time, the Victorian era, aspired to create images of sharp-

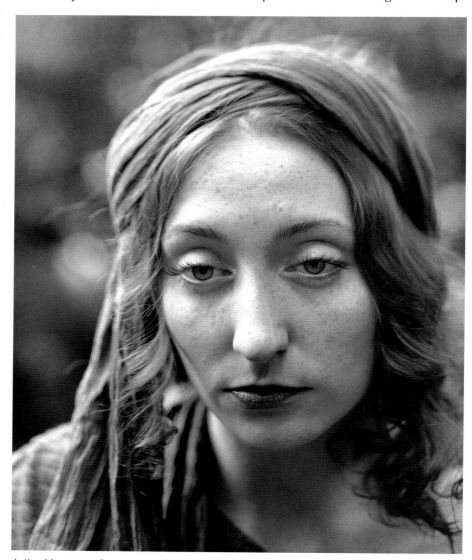

Julia Margaret Cameron printed from large, wet collodion glass-plate negatives. Encountering many technical difficulties due to a makeshift darkroom, many of her prints were blemished by streaks and dust spots. She later made contact albumen prints, which could be toned brown and purple. Some of her negatives were also printed using the carbon process. Inspired by Cameron's style, I photographed Mary on Kodak Tri-X film under open shade. I used a Toya 4"x5" camera with a Nikor 210mm lens for the shot.

Emulating Newman's penchant for photographing artists, I photographed sculptor Roger Wing. He stood patiently as I looked through the ground glass of my 4"x5" camera. By mixing strobe with daylight, I was able to create a natural-looking environmental portrait. I placed a strong kicker light out of the frame to highlight the subject's right side. (Camera—Toya 4"x5"; Lens—Nikor 210mm; Film—Kodak Tri-X; Lighting—mixed natural and strobe light)

ness and detail, she chose to shoot her subjects in soft focus and allowed the imperfections of the large glass plate negatives to show in the prints.

Cameron's "models" were either members of her family or good friends. Her close personal relationships with her subjects enabled Cameron to tap into a deeper level of truth, contributing to the lasting success of her portraits. Her images

not only give us insight into the Victorian era but also reveal less documented aspects of their lifestyle as her subjects literally "let their hair down."

Others. Noted portrait photographers of Cameron's era include: David Octavius Hill and Robert Adamson (known as Hill/Adamson), Nadar, Edward Sheriff Curtis, Lala Raja Dean Daya, Gertrude Käsebier, and Mathew Brady.

▼ ARNOLD NEWMAN

By 1938 photography had become more of an accepted art and an affordable hobby among the public. Picture magazines, like *Life* and *Look*, became "windows to the world." Americans were now getting a closer look at movie idols, politicians, and the leaders of the time.

At that same time, a young photographer by the name of Arnold Newman was honing his craft: envi-

ronmental portraiture. Living in West Palm Beach, Newman was creating socially conscious images of the urban poor. It was his portraits of artists in their environments that caught the eye of Beaumont Newhall and Alfred Stieglitz, prominent photographers who encouraged him to move to New York City in 1945.

Working primarily with a large format camera, Newman meticulously created environmental backdrops that related to the subject he was photographing. Using well placed hot lights, he created a visual mood that provided the viewer with insight into his subject's passion or personality.

Others. Noted portrait photographers of Newman's era include: Yousuf Karsh, Philip Halsman, Lisette Model, Gordon Parks, Bill Brandt, Irving Penn, David Seymour Chim, and Richard Avedon.

▶ ANNIE LEIBOVITZ

It was the late 1960s and color photography was the norm. Dr. Harold Edgerton's 1931 invention of the strobe light had developed to the point of being portable—and, therefore, indispensable—to portrait photographers shooting either color or black & white films with slow ISOs. America was embroiled in a period of social turmoil and an obscure alternative music magazine in San Francisco, *Rolling Stone*, gave an art school student by the name of Annie Leibovitz her first assignment.

What made Leibovitz's work stand out from other celebrity portrait photographers of the time was her ability to capture the personal side of her subjects. Up until that point, publicists for the various celebrities had carefully controlled the way their clients were portrayed to the public in photographs. Public figures were portrayed as glamorous, successful, and dreamy. Leibovitz, however, stripped away the veneer and created portraits that revealed the more complex human qualities of her subjects. In essence, she put a human face on the celebrity—one with which the public could identify.

As her photographic style developed, so did her concepts. As *Rolling Stone* became more popular, Leibovitz's images of rock stars became more iconic. When I worked with Leibovitz in 1981 she was in a

Shooting color portraits outdoors can be challenging. Mastering the balance of flash to ambient light can open the door to all sorts of creative possibilities. For this family portrait, Sionann, Kevin, and their son Malachi braved a cool, stormy afternoon. I emulated Leibowitz's outdoor portrait style by overpowering the ambient light with the strobe light. (Camera—Hasselblad; Lens—120mm; Aperture—f8; Shutter speed—$^1/_{250}$ second; Film—Kodak 120EPP; Lighting—Strobe light with softbox and ambient light.

career transition. She was given an exclusive contract with *Vanity Fair* and was about to end her 11-year relationship with *Rolling Stone*.

At that point in her career, she was shooting her portraits in medium format and lighting them with strobes. The effective use of strobe fill light outdoors helped establish her trademark style in color portrait photography. Using the medium format camera allowed Annie to sync the strobe to $^1/_{500}$ second; with the right lighting ratio she could then create a portrait that brought out the subject and flattened the background so that it almost appeared unreal.

Others. Portrait photographers of note include: Diane Arbus, Herb Ritts, Bruce Weber, Arno Rafael Minkkinen, Greg Gorman, Douglas Kirkland, Mary Ellen Mark, Robert Mapplethorpe, Cindy Sherman, and Carrie Mae Weems.

Portrait photography is forever evolving through a complex process of technological advances, societal conventions, and individual creative vision. As you study both contemporary portraits and portraits by artists of the past, however, you will begin to recognize a number of patterns and familiar themes. The reason why these themes keep appearing is that they are successful; they work. They help the photograph succeed by ensuring that the viewer understands its intention, either consciously or subconsciously.

> **"We sometimes don't realize that the work that is possibly our strongest work is intimate and right in front of us."**
> —*Annie Leibowitz*

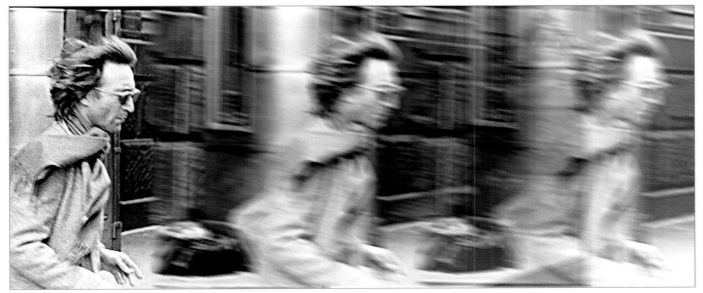

I took this photo of John Lennon in November of 1980. I call it *Passing of a Cultural Revolution*. After scanning the negative, I used the filters in Photoshop to create the visual transformation.

2. FILM CAMERAS

*N*ASA HAS PROVEN THAT EVEN A MONKEY CAN TAKE A picture. The only requirement is pushing a button. Creating a *portrait*—something that does more than just record the light reflected off your subject—requires knowledge, imagination, and experience. In chapters 2 through 4, I will discuss the equipment options available, as well as some of their unique characteristics. You will find different combinations will meet your

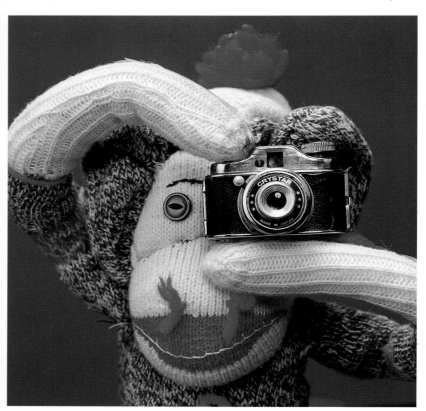

Since I was unable to use a real monkey from the zoo, I had to settle for a sock monkey. He turned out to be a great subject and very easy to work with. (Camera—Hasselblad; Lens—120mm with 2x close-up ring; Film—Kodak 100VS; Lighting—Strobe)

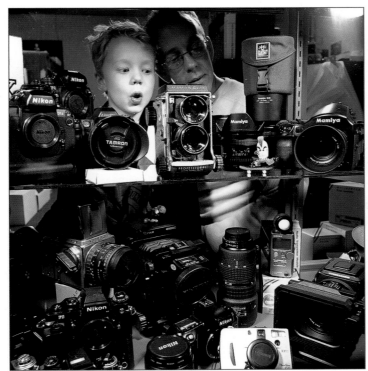
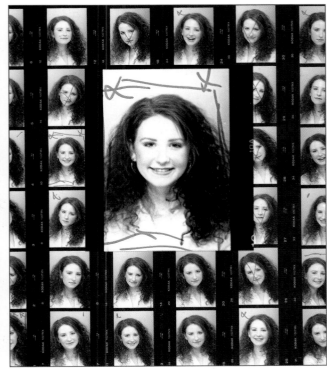

Left—It's not easy to decide what camera to buy with so many choices and price ranges available. In this photo, John (of WebbCam Photo) and his son Andrew ponder some of the choices in the display case. (Camera—Hasselblad; Lens—50mm; Film—Kodak 100G; Lighting—Strobe) **Right**—This is an example of a 35mm contact sheet. The photo session was for a model/actress, Ashley, who was looking for a good headshot to begin her career. I used a red grease pencil to cross out the ones I did not like, and red dots for the ones we picked. Editing is a very important part of training your vision. Spending time to closely examine your contact sheet will teach you what works and what doesn't work in a portrait session. It helps if you have a good magnifier or loupe to enlarge the images. Scanning your negatives and looking at them on a computer screen is also a great way to edit your work.

needs in different situations. We'll begin by looking at film cameras and digital capture options.

There are three types of film camera formats. Each format corresponds to the film size the camera accepts. This is important because the size of the film directly affects the quality of the final print. The fewer times you need to magnify (enlarge) the negative to reach your desired print size, the better the quality of the print will be—so bigger negatives mean better prints.

▼ THE SMALL FORMAT (35MM)

The most widely recognized camera is the 35mm, part of the small format

family. Its ability to adapt to extreme lighting and weather conditions, as well as its portability, make it a favorite pick for photojournalists, headshot photographers, and, with the advancement in film quality, many wedding photographers.

One important asset of small format cameras is their "fast" lenses (lenses with apertures of f2.8 or larger). This enables you to handhold the camera, open up your aperture, and shoot at a shutter speed that is fast enough to freeze action. It also permits handholding the camera in low light conditions. As a rule .of thumb, when handholding your camera, you should keep your shut-

ter speed near or equal to the inverse of the focal length of the lens ($1/_{\text{(focal length)}}$ second). For example, to prevent camera shake while using a 200mm lens you would want to shoot no slower than $1/_{250}$ second. You may, however, be able to shoot successfully at slower shutter speeds if you stabilize your camera by leaning against a wall, tree, pole, etc.

Because of the reduced depth of field, opening the aperture to its widest setting also offers the ability to throw a distracting background out of focus. When shooting portraits, however, this reduction in the depth of field means that you need to pay careful attention to the focus.

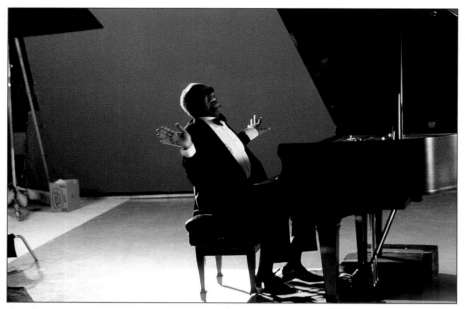

Another way to keep your 35mm camera quiet is to rent or buy what is called a blimp. This is a metal housing unit that fits around your camera. It has different sized tubes to fit the focal lengths of different lenses. When I was photographing Ray Charles on a sound-stage, I used a blimp housing over my 35mm SLR cameras so I could photograph while they were filming with sound. (Camera—Canon EOS 1n; Lens—200mm; Film—Fujichrome 1600; Lighting—Tungsten)

Depending on your distance from the subject, shooting with a 200mm lens at f2.8 with a 35mm camera will give you a depth of field of only about 3"–6". It is therefore best to focus on the eyes of your subject to ensure their face remains sharp.

SLRs and Rangefinders. The 35mm camera can be divided into two major categories: the single lens reflex, more commonly known at the SLR, and the rangefinder. The differences between them have to do with the viewfinders.

The SLR allows you to see precisely what you are about to photograph because the image in your viewfinder is created by the same lens as will be used to expose the film. This is possible because a mirror, placed inside the camera at a 45° angle, projects the reflection of your subject through a prism, which flips the image, and into your viewfinder. When you push the shutter button to take the picture you hear a "click." This is the sound of the mirror flipping up and allowing the light to expose the film. While this noise (called mirror slap) is not generally objectionable, it can become an issue in a sound-sensitive situation—such as when photographing a performer.

In contrast, a rangefinder does not contain a mirror or prism. Instead of looking through the lens, its viewfinder is separate from the lens. Therefore, when you push the shutter button you only hear the quiet sound of the film curtain opening and closing. This allows you to be more discrete when shooting in public places and performance halls. However, because the viewfinder and the lens are in different positions, framing problems (called parallax) can occur with rangefinders. These are especially pronounced when working close to a subject.

Frames Per Roll. Another advantage of shooting portraits with a 35mm camera is the quantity of frames per roll—36 exposures. When your subject's time is limited and you only have fifteen minutes to come up with a great portrait, it is reassuring to know that you can set your camera on motor drive and shoot a lot of film in a short amount of time. This is not the ideal condition for a meaningful portrait, but it's a very real scenario in the world of professional photography.

Affordability and Choices. A good 35mm camera with a 50mm lens can be purchased for as little as $200. When you are thinking about purchasing a camera, the number of choices can cause confusion. Try to keep in mind both your budget and the features you really need. Do you really need a camera that shoots twelve frames per second, or one that automates every control?

◤ THE MEDIUM FORMAT

The medium format camera is considered the "professional choice" for portrait photography. No doubt one of the reasons for this assertion is the sheer cost of the camera. A professional medium format camera with a standard 80mm f-2.8 lens ranges from $1,800 to $7,500. This is a big

investment if you are just starting out, but in the long run the medium format camera will give you the most flexibility and the highest quality of image reproduction.

Choosing a Medium Format Camera. If you want a simple, low-budget introduction to shooting with medium format there are some interesting options. The least expensive is the Holga camera. The Holga, a "toy" camera in the same family as the legendary Diana camera, costs from $15 to $20 with a built-in flash. It is made of 100% plastic and each model comes with its own unique light leaks (although unpredictable, these can create some interesting effects). It even switches between rectangular (6x4.5cm) and square (6x6cm) formats on 120 film.

If you don't feel comfortable with surprising results another inexpensive alternative would be the Seagull Twin Lens Reflex (TLR) camera. The price for these cameras ranges from $170 to $300. TLRs have two lenses, one for viewing your subject and one for exposing the film. The mirror that projects the image onto the viewing lens is fixed, keeping the camera quiet when pushing the shutter button. Unlike the 35mm SLR, the TLR camera does not use a prism to correct the image on the ground glass; therefore the image in the viewfinder is reversed—what is on the left in the scene or subject is on the right in the viewfinder, and vice versa.

Another consideration when using a TLR is correcting for parallax. Since the viewing lens is above the lens that records onto the film there is a slight discrepancy in how the image is framed by the taking lens vs. the viewing lens. The distance between the two lenses, the focal length, and the subject-to-camera distance all affect the variance of parallax. A short focal length or a close subject increases the discrepancy. It is easy to correct by repositioning your framing to match the position of the lower lens with the viewing lens.

A final word about TLRs—for a number of reasons the TLR is frequently overlooked as a portrait camera but, like the 35mm rangefinder, it is a quiet camera that allows for unobtrusive photography. The best way to look at the image on the ground glass is by looking down into it. For that reason the TLR is some-

Michael and Ali were trying to recreate the painting American Gothic for me. I'm not quite sure we succeeded, but we had fun trying. One good point about using the medium format camera is that the larger film format made it a lot easier to see where we failed! (Camera—Hasselblad; Lens—120mm; Film—Kodak Tri-X; Lighting—Open shade)

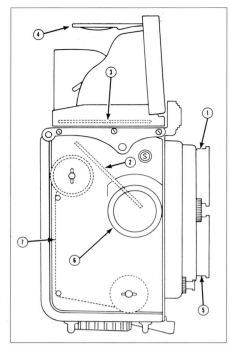

The anatomy of a TLR camera: viewing lens (1); Light passing through viewing lens hits the mirror angled to reflect it on viewing screen above (2); viewing screen (3); Pop-up magnifier attached to hood aids with focusing (4); taking lens (5); Focusing knob (6); Film unrolls from spool, passes behind taking lens (7). Here you can see the difference between what you see through the viewing lens (1) and what the film records through the taking lens (5) results in a variation called parallax. This can be corrected by adjusting the camera position. Diagram courtesy of Yashica.

times called a waist-level camera. Except for the Mamiya TLR, these cameras have fixed lenses.

Why Buy Medium Format? The medium format camera is heavier than a 35mm SLR, it can be clumsy to handhold, lenses and accessories can be prohibitively expensive, it's noisy, the image is reversed on the ground glass, and at best you get twenty-four frames on a roll (twenty-four with a 220-film back, twelve with a 120-film back). So why

commit yourself to all those potential drawbacks when choosing a portrait camera? The following will shed some light on this dilemma.

First, film size matters. In order to make an 8"x10" print from a 35mm negative (which is 1"x1$\frac{1}{2}$" [24mm x 36mm]) you have to enlarge the negative seven times. The more times you magnify a negative the more apparent the film grain is in the print. In portrait photography, having visible grain can distract from the subject's skin tones. Most medium format cameras use 2$\frac{1}{4}$"x2$\frac{1}{4}$" film (6x6cm), 2$\frac{1}{4}$"x 2$\frac{3}{4}$"(6x7cm), or 2$\frac{1}{4}$"x1$\frac{5}{8}$" (6x4.5cm) film. To make an 8"x10" print from a medium format negative you only have to enlarge the negative four times. This is a clear advantage.

Another advantage of shooting with a medium format camera is the interchangeable film back (although Fuji, Mamiya, Pentax, and Bronica manufacture medium format rangefinders that have fixed backs, which you load as you would a 35mm SLR). The advantage of an interchangeable back is that you can switch to an NPC Polaroid back, purchased as an accessory to the camera, to test your exposure and lighting before you shoot. It also means

you can change film types in the middle of a roll. For instance, if you decide, after shooting five frames from a roll of color film, that you want to shoot black & white, you simply remove the film back from the camera and replace it with another containing black & white film. A dark slide prevents the film from being exposed when you remove the back.

Manual medium format cameras also offer consistency and simplicity. You don't have to worry about batteries wearing out or electronics breaking down. If you professionally maintain your camera at least once every two years, it could outlast you. When you go on a professional portrait shoot you don't get a second chance. Your equipment is the last thing you need to worry about. Your only concern should be creating the best possible image.

Accessories. Of course you can enhance your medium format camera system by purchasing accessories. For instance, if you have a manual Hasselblad camera you can buy a corrective prism magnifier that rights the image in the viewfinder, or you can purchase a winder that advances the film frame automatically. The list goes on …

Tips Portrait sessions can get very complicated—especially when working with a difficult subject or under adverse conditions. The fewer variables you deal with, without limiting your creative inventions, the better chance you'll have of achieving success. Setting the lights and shooting a Polaroid before your subject arrives can reduce your stress. Hiring a good photo assistant can also help the creative flow.

Final Thoughts. The medium format camera is a good choice for portrait photography. The size of the camera allows for handholding, you have a larger viewfinder to visually scan corner to corner, and you have a larger negative to create high quality prints.

▶ THE LARGE FORMAT

What do acclaimed portrait photographers Irving Penn, Richard Avedon, Arnold Newman, and Yousuf Karsh have in common? They have all taken some of their classic portraits with a large format camera.

While the large format was, in terms of history, the first camera of photography, today it is probably the last camera thought of when choosing a format for portraiture. The name "large format" (a.k.a. the view camera) intimidates even seasoned portrait photographers. Draping a black cloth over your head and focusing by expanding and contracting bellows may not be the best way to make your subject feel at ease; you may even feel it stifles your creative edge by dampening the spontaneity of the moment. However, if you are striving to create portraits in the style of "the greats" you may want to consider a large format camera.

Types of Cameras. Large format cameras are divided into three categories: the field camera, the technical camera (a.k.a. the studio camera), and the press camera.

The field camera is lightweight, rugged, and compact, making it a

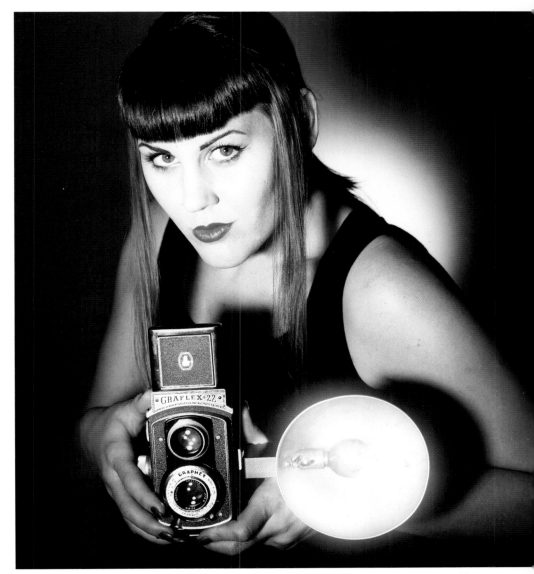

Inspired by Weegee (the professional name used by the 1930s–1940s New York City photojournalist Arthur Fellig), I set up this portrait of Athena Lourdes holding a Speed Graflex TLR camera. The apparent light from the flash was created in Photoshop. I selected the area for the flash effect using the Elliptical Marquee tool. Using the Eraser tool at 50% opacity, I then rubbed inside the selected area to remove image data and create the glow. (Camera—Hasselblad; Lens—120mm; Film—Kodak EPP; Lighting—Direct strobe light)

good choice for portraits. Most field cameras have a flatbed base that is hinged to the rear standard of the camera. While limiting some of the camera's rear movements, this does not limit the photographer's ability to create dynamic portraits.

The studio camera is more versatile than the field camera. This type of camera rests on a monorail, which gives the photographer more control over perspective. This control makes the studio camera well suited for architectural and commercial studio work where critical perspective correction is imperative.

Press cameras, as the name indicates, were large-format hand held cameras primarily used by photojournalists before the invention of

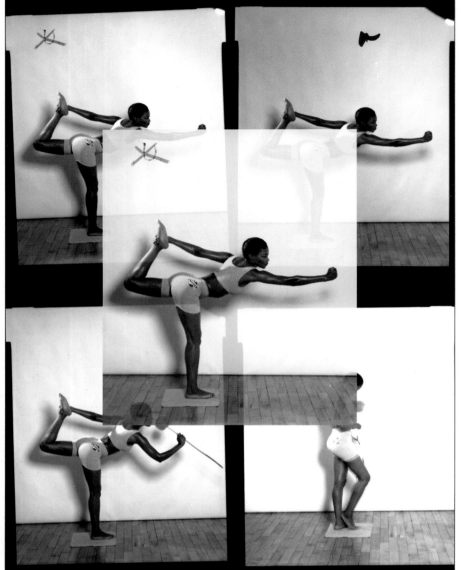

Left—As part of an ad campaign for the Crunch Fitness Centers, I created a series of photographs parodying well-know images. Here, model/singer Jewel Turner posed beautifully in the stance taken by Grace Jones on the cover of her album *Island Life*. (Camera—Toya 4"x5"; Lens—210mm; Film—Plus X Pan; Lighting—Strobe) Above—It is good idea to "frame-up" your subject with your hands or a cropping device. Facing Page—This image demonstrates the application of selective focus with a large format camera. The sculptor Scot Kaylor stood parallel to the film plane. I tilted and swung the back standard away from the subject to throw the lower part of the image out of focus. Then, I tilted the front standard to keep the face sharp. This effect can also be achieved in the darkroom by tilting the easel when exposing the negative, or digitally using the Blur tool in Adobe Photoshop. (Camera—Sinar P2 4"x5"; Lens—210mm; Film—100 VS)

the 35mm camera. The press camera has little or no perspective movements and is focused through a viewfinder, not the ground glass. The Graflex Speed Graphic camera was the workhorse of many great portrait photographers during the '30s, '40s, and '50s, like Arthur Fellig (a.k.a. Weegee), Dorthea Lange, and Diane Arbus. These cameras are no longer manufactured but can be purchased used for about $200 to $300. If you are apprehensive about giving up the mobility of shooting with a small

or medium format but want a 4"x5" negative, a press camera such as the Graflex Super Graphic, Super Speed Graphic, or a Speed Graphic could be your answer.

Why Use the "Big Box" to Take a Portrait? Shooting with a large format camera forces you to be more contemplative about your subjects and their surroundings. Since the camera is heavy and needs to be mounted on a heavy-duty tripod, it is to your advantage to previsualize the scene before you set up. You will not

be able to move around during the session as you would with a hand-held camera.

The large format camera will also render the highest quality image on film. If you are seeking optimum resolution, tonality, sharpness, and color saturation in your final image, choose large format. The size of a large format negative begins at 4"x5" (with the use of a reducing back to create a smaller format negative). It can get even bigger with one of the six 20"x24" Polaroid cam-

eras that exist in the world and can be rented by the day. (Alternately, Wisner manufactures a 20"x24" field camera and a Polaroid processor that is about 200 pounds lighter than the Polaroid camera. It costs about $15,000 for the package.) Increasing the size of your negative reduces the need to magnify it when making enlargements, leading to a higher quality print.

Large format cameras also share some basic components that differentiate them from cameras of other formats. As you will see in the following section on camera movements, these structural differences offer some additional creative controls that can make the large format appealing for portraiture. The basic components of a large format camera are:

1. The back standard secures the film holders or Polaroid back and is the ground glass through which you view your image. The back standard movements can change the shape of your image by altering the perspective.
2. The bellows expand and contract on a monorail. This movement controls the focus.
3. The front standard holds the lens, which contains the shutter mechanism and the diaphragm controls. The front standard, when applying the Scheimpflug effect, will give you optimum focusing.

Camera Movements. Camera movements distinguish the large format camera from other formats. These movements alter the perspective and focus of the camera. In portrait photography, they can create opportunities for selective focusing and optical distortion. The five movements are:

Rise—A vertical rise of the back or front standard from the neutral position.

Fall—A vertical fall of the back or front standard from the neutral position.

Slide—A horizontal slide of the back or front standard from the neutral position.

Tilt—The back or front standard is rotated around its horizontal axis.

Swing—The back or front standard is rotated around its vertical axis.

Large format camera movements are simple to comprehend but difficult to apply, and the above are simply definitions of view camera components and their movements. It takes a lot of practice to begin to

feel comfortable using them. There are some very thorough reference books on the large format camera listed in the resources section at the back of this book.

▸ BEFORE YOU BUY

Whatever type of camera you decide to buy, the important considerations are durability, warranty, and accessories. Does the camera manufacturer have a good track record? Will both the manufacturer and the camera store stand behind the product with a good warranty? Does the camera system give you room to grow? You will want to be sure the manufacturer has a long list of lenses, flashes, and remotes that you can add to your equipment list as time and your budget allow. In addition, you should consider digital compatibility. It is best if the lenses you buy for your camera can also be used with the manufacturer's digital cameras. As digital cameras become more common in portrait photography, you do not want to get stuck with lenses that are not compatible with the new technology. For more on this topic, proceed to the next chapter.

Camera movements distinguish the large format camera from other formats and allow you to alter the perspective and focus of the camera.

*I*N THE DIGITAL WORLD YOU NO LONGER "TAKE A picture," you "capture an image." A photograph referred to as "grainy" in film photography is referred to as having "noise" in the digital capture. As in traditional photography, however, digital imaging is still about capturing light. Instead of using film, the digital camera translates reflected light into

A point-and-shoot camera is a great introduction to digital photography. I photographed Jaime in the studio with white seamless paper as a background. A bank light was placed to her left and a white reflector was placed to her right. A hair light was added on a boom stand and two strobe lights were placed behind the subject to illuminate the background. (Camera—Hasselblad; Lens—120mm; Film—Kodak EPP; Lighting—Strobe)

combinations of zeros and ones that can be read by a computer. These "bits" (binary digits) are similar to a single silver halide crystal found in film. The more bits per square inch, the higher the resolution and the less noise (apparent grain) in the final image.

Digital offers some great features. First, you can immediately view the captured image on the camera's LCD (Liquid Crystal Display), or on a screen if you are hooked up to a computer. That means you can evaluate your shot right away and know if you captured the image you wanted without waiting for film to be processed. Digital photography also eliminates the need to spend money on film, Polaroid material, chemistry, etc. (however, some other new costs will be added). Once you capture the image on a memory card in your camera or send it directly to your computer, the image is ready to be managed and edited as you like. The computer becomes your virtual darkroom and allows you adjust, manipulate, e-mail, and print your digital image.

While it does offer some important advantages, digital imagery also creates some new concerns for professional portrait photographers. For example, the final print quality (depending on the print process) may not equal that of prints made from film. In addition, the stability of these images over time has not yet been proven. Also, while capturing a digital image, deterioration can occur through loss of power or the interruption of a magnetic field.

Film's capacity to record image information still exceeds that of digital imagery—but probably not for long. For many established photographers, film is still the easiest and most cost effective way to create images. However, digital technology is constantly improving and the costs are coming down. Is it worth trading in your cameras to go digital? It all depends on what you are going to do.

Even if you prefer to stick with film for now, the digital revolution is having a profound influence on photography. If you want to compete in the marketplace, you should be familiar with its applications and potential.

◤ IN THE PORTRAIT WORLD

If you are operating a busy portrait studio—photographing families, babies, etc.—digital has some great advantages. You can photograph your clients, download the images onto a computer screen, and show them their choices right away. After they have selected the images they like, you can use a software program

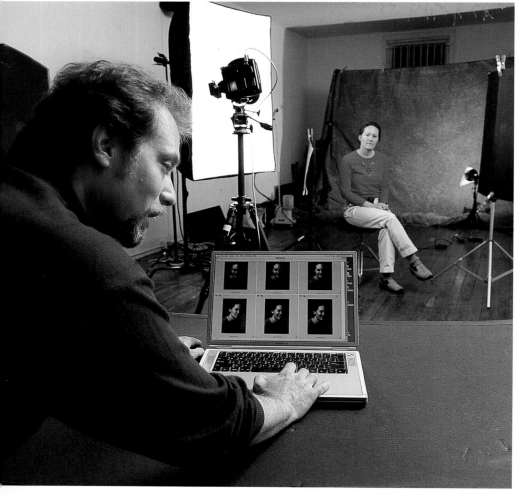

After capturing some images with his Kodak digital camera, photographer David Moser edits his images of Elaine Lander on his Macintosh laptop.

like Photoshop to crop, retouch, and organize them. You can then print the final images on photo-quality paper and present them to your clients—all without ever leaving your studio! If you are on a tight schedule, you can simply e-mail the low-resolution images to the client's home computer (just as you would give them proofs) so they can make their selections at their leisure.

While this is a terrific scenario in terms of your workflow, it will require a substantial investment of both time and capital to get started. To begin you will need to buy or lease a 35mm-type digital camera (about $2,500) or a digital back for your medium or large format camera (about $10,000–$25,000). You will also need to have a fully loaded computer with image management software that you or your studio manager are proficient at operating. You will need to understand color management and how the color on your monitor will compare to the color of the final print, either from your high-end color printer or an outsourced printer.

▶ THE DIGITAL CAMERA

Digital technology is changing so rapidly that information is often out of date shortly after it is written. With this in mind the following will serve as an overview of what you should think about when considering a digital camera.

CCD or CMOS. Digital cameras use a CCD (Charge Coupled Device),

or a CMOS (Complimentary Metal Oxide Semiconductor) sensor to convert light energy into digital electrical signals that can be stored in the computer as data. The CMOS sensor is newer on the market and less expensive to produce than the CCD, which is reflected in the prices of cameras equipped with them. However, CMOS sensors are more prone to noise (the digital equivalent of graininess) and lack the quality and resolution of the CCD sensor. While this makes CCD the standard for now, there are new image-capture devices in the works and the folks that produce the CMOS are making improvements to their product.

As noted above, the function of the the CCD sensor is to capture light. It does this in analog form, then passes the captured data through an analog-to-digital converter (ADC) where a microprocessor interpolates the data to create natural colors. Once the image is converted from analog to binary form (digitized) it can be immediately viewed on the liquid crystal display (LCD) of your camera. Like a Polaroid, the LCD allows you to view the captured image immediately and make any necessary changes.

Resolution. If your objective in buying a point-and-shoot fixed-lens digital camera is to take snapshots to e-mail to your family, a camera that captures images at about 640x480 pixels will probably be sufficient. If , however, you are planning to print your images to 4"x6" or larger, you will need a 2–3 megapixel (MP) camera. For larger prints, you'll need to be able to create even larger images (more MP). The bottom line is, the more pixels your camera can capture, the more money you're going to spend—so evaluate your needs carefully before making a decision.

When comparing the resolution of digital cameras, be sure to determine whether the resolution advertised refers to optical or interpolated resolution. This is important because they are not the same thing. The optical resolution gives you the truest measure of how sharp your image will look. The interpolated resolution reflects the results of digitally expanding the image by adding new pixels in between the ones that were actually captured—basically "guessing" what the image would look like at a higher resolution. This can lead to a fuzzy image when enlarged.

Don't be fooled by the advertising. Make sure that you know the bottom line.

Storing Your Images. The final step in the digital process is storing and transferring your images. Most digital cameras use removable storage devices that can store hundreds of megabytes of data on a single card. SmartMedia, Memory Sticks, and CompactFlash cards are examples such memory devices. After you capture your images, the memory card can be removed from your camera and placed in a card reader that is connected to your computer by a USB or FireWire cable.

If your card becomes full before you are done shooting, you can free up its memory by downloading the images to your hard drive, or you can place a new card in your camera and store the old one. There is nothing more frustrating than being on a location shoot and running out of film; the same holds true with digital memory. If you do not have a way to download your images on site, be sure to have an extra memory card.

Most professional digital cameras also allow you to send your captured images directly to your computer or laptop while you are shooting. This can restrict your mobility, but this problem is being addressed by manufacturers, like LightPhase, who have created portable systems that can connect to a mini-laptop using a FireWire cable.

Image Formats and Data Compression. When an image is cap-

The digital capture on an LCD screen eliminates the need for proofing on Polaroid. After the image capture, the photographer can evaluate the lighting, makeup, expression, and even color balance in the image. The process of creating digital images takes a little getting used to, but once you reach the comfort zone digital can open up many creative doors and streamline your workflow.

tured, it is either saved as RAW data or converted to a JPEG (Joint Photographic Experts Group) or TIF (Tagged Image File) format.

JPEG is the most common format for digital camera files. The reason for this preference is that the JPEG format can reduce the image file size up to ten times without significantly degrading the quality of the image to the viewer's eye. As a result, the images look good and require less memory to store (meaning you can take more shots on each memory card). JPEG, however, uses what is called "lossy" compression, meaning that it removes image data that is deemed to be redundant or irrele-

vant. When compression is used in moderation, it is hard to distinguish a 1MB JPEG image from a 6.13MB TIF image (which employs "lossless" compression). The more the files are compressed, however, the more the compression is likely to become visible as artifacting (a telltale grid-like pattern in the pixels that results from the digital processing).

In contrast, TIF files employ what is called "lossless" compression. In this compression strategy, the data is reorganized in such a way that it requires less memory to store but no data is eliminated. While there is no loss of visual quality, TIF compression does not allow the file size to be

reduced as dramatically as JPEG compression does. As a result, fewer images can be stored on any given memory card.

To make the most of your camera's digital chip, you can use the RAW file format, which yields a true digital negative that has not been processed or compressed in any way by the camera. This produces a wider bit range than the TIFF or JPEG format and eliminates any degradation or artifacting from compression. You will need a software module to open the images and they will take longer to process. A basic version of the RAW file processing software is packaged with most cameras, or you can buy an enhanced version from Adobe (the camera-RAW plug-in) that allows you to access and open RAW files within Photoshop. The Adobe plug-in offers much greater controls than other RAW file processing applications.

White Balance. White balance is a digital control that replaces the need for color correction filters used with tradition color films. The digital camera finds the "white point" in the scene and corrects the other colors in relation to it.

The automatic white balance control can be misleading, especially if there is one dominant color in the scene. It is better to purchase a digital camera that allows you to override the automatic white balance and set the white balance manually for daylight, overcast, fluorescent, tungsten, etc.

Some digital cameras also allow you to preset the white balance. This is simply done by pointing the camera at a white card or wall to record the color temperature. Until you reset it, all images captured after that point are color corrected based on that white balance measurement.

Batteries. Batteries power the LCD, the image sensor, and the microprocessor. Before you buy, find out what kind of battery the camera uses. Try to find one that uses alkaline batteries and buy rechargeable ones, if they are available. You need to be charged up to shoot, and digital cameras love to eat batteries. Always have an extra set on-hand and ready to go.

◤ MEDIUM AND LARGE FORMAT DIGITAL BACKS

If you own a medium format or a large format camera and you want to go digital, you're in luck—sort of. The good news is that all you need to buy or lease is a digital back (providing your camera has a removable back). The bad news is that it comes at a price. Digital backs start at about $10,000 for medium format and go as high as $25,000 for large format. If you are expecting to use digital imaging for a high volume of work, the investment will be worthwhile in the long run. Working in a digital environment speeds up the workflow and allows a lot of the postproduction work to be completed in the studio. This means no more waiting for the film from the lab, sending out

the work to be retouched, or even outsourcing the printing.

Digital backs work just like the digital cameras discussed earlier in this chapter. The big difference is the significant increase in the amount of data the backs can capture. This translates into higher resolution images. For example, the Kodak DCS Proback Plus has a 16MP sensor (4080x4080 pixels) that generates a 64MB RGB file. This will allow you to print a 40"x40" image with little noise.

◤ SCANNING: THE OTHER DIGITAL CHOICE

If a digital camera is not in your budget—or if you feel comfortable with the film cameras you are already using—think about buying a film or flatbed scanner for your digital imaging needs. A scanner digitizes film and flat art, allowing your computer to read the images. Add image editing software, such as Adobe Photoshop, to your computer and you're in business.

Types of Scanners. If you work primarily with transparencies and negatives, purchase a film scanner. A 35mm film scanner is relatively inexpensive and allows you to scan at high resolutions. Multiformat film scanners are pricier, but if you work with medium or large format film they should be a consideration.

Flatbed scanners are primarily used for digitizing flat art, but can be more versatile than a film scanner. Some models are also available with

Working with a good scan makes digital imaging a lot easier. In all cases, the desired output should be considered with determining the needed resolution for the scan. In the images above, the portrait on the left was scanned at a high resolution suitable for printing. The image on the right was scanned at a low resolution. Although it looks bad in print (where higher resolutions are required), it would actually look just fine on screen (like on a web site) where lower resolutions are needed.

a transparency adapter that allows you to scan film and negatives up to 8"x10".

Drum scanners are a third option. While they can produce very large, high-resolution files, they are extremely expensive and therefore impractical for private use. It is best to leave the high-end scanning jobs to a digital service bureau; they have trained professionals that will save you time and money.

Resolution. If you decide that you would like to scan your own images there are some terms you should know. The resolution of a scanner (the amount of data it records in a scan) is measured in dots per inch, more commonly referred to as dpi. The dpi is the same as the ppi (pixels per inch) measurement that is used when discussing the resolution of digital cameras and computer monitors. How your image will be used will determine your choice of final resolution.

· If your image is only intended for the Internet, the resolution should be 72dpi. Most computer monitors can only display 72ppi, so providing a higher resolution file will not improve the appearance of your image; it will only result in longer upload/download times.

· If you are going to print out an image on your printer or use the image for a magazine or book, the final image should be approximately 300dpi.

· If you are printing an image for fine art or your portfolio, the final image resolution may need to be as high as 4000dpi. The lab that will be printing your images will be able to advise you of the correct setting.

Once you've determined the needed resolution for the image, you need to set the correct resolution on your scanner. To do this, you must

consider both the film size and the size of the final image. For example, if you are scanning a 4"x5" negative and plan to print it out as an 8"x10" image with a resolution of 300dpi, the resolution of your 4"x5" scan will actually need to be 600dpi. This is because when you double the area the pixels must cover (from 4"x5" to 8"x10"), you halve the number of pixels left to cover each inch (from 600dpi to 300dpi). To determine the needed increase in resolution, divide the longest dimension of the final image, here 10", by the longest dimension of the film being scanned, here 5". This calculation (10 ÷ 5 = 2) yields a factor or 2X, so you need to multiply the final needed resolution (here 300dpi) by 2. The equation would be 2 x 300dpi = 600dpi.

Working with a good scan is the same as working with a good negative; there is no substitute. You can make improvements with your imaging software, by adjusting the levels histogram, the curves, etc., but working with a low-quality scan, like an poorly exposed negative, is time consuming and rarely yields as good a result.

▶ A FINAL WORD ON DIGITAL [ALMOST]

Digital tools for photography are constantly changing and improving the way images are shot, sent, and presented. There are many great in-depth books on the various areas of digital photography. Like any new camera, device, or photographic invention, there is a fascination and a hope that by employing the new technology, you will take better pictures. Keep in mind, however, that these are really only tools for capturing light. Responsibility for the quality of the image still rests on the photographer. So, no matter what light-capturing device you use, creating a good portrait is up to you.

▶ LENSES
[AND THIS IS REALLY THE LAST WORD!]

The effective focal length of a lens (whether it is considered wide-angle or telephoto, for example) is related to the size of the image area to be exposed. Therefore, it will be different depending on whether the lens is used to expose film (a larger area) or a digital chip (a smaller area). Because the image area is smaller when you use your lens on a digital camera, the effective focal length of the lens is shorter. This is why camera manufacturers display focal-length conversions between analog (i.e. film) and digital for their lenses. For instance, a 20mm lens is equivalent to a 26mm lens in digital; a 28mm lens equates to a 36mm lens, and an 85mm lens converts to a 111mm lens. Keep this in mind as you read through the next chapter.

Tips **If a store is selling a point-and-shoot digital camera with a 100x zoom, this claim does not reflect the quality of the lens. Instead, it refers to digital zoom software that will magnify your captured images much as the imaging software on your computer would. Using the digital zoom results in lower image quality than using the optical zoom [the term used to describe the magnifying power of the lens itself]. Therefore, be sure you know the numbers for each as you compare models and make a buying decision.**

4. THE LENS

*N*OW THAT YOU DECIDED ON A CAMERA FORMAT, IT IS time to choose a lens. Most stores will want to sell you a package: camera, normal-focal-length lens, camera case, and—of course—lens tissue. However, you may want to consider buying the camera body and the lens separately so you can get exactly the lens you want. Although lens choice is a personal preference, before making your selection there are few issues to consider.

▶ ANGLE OF VIEW

The longer the focal length (see below), the more the image will be magnified on the film and the smaller the angle of view will be. As a result, you may need to move farther from the subject to achieve the desired composition. In some circumstances—such as when working in a small area with a large group—this may dictate the lens that you'll need to use. The larger the film format, the longer the focal length needs to be in order to maintain the "normal" angle of view (the angle of view with a normal focal-length lens).

▶ FOCAL LENGTH

Normal Lenses. As noted in the previous chapter, the effective focal length of a lens is related to the size of image area to be exposed. For most image formats, a lens is considered "normal" (i.e. not wide-angle or telephoto) when its focal length is about equal to the diagonal of the area it is used to expose. For this reason, a 50mm lens is considered normal for a 35mm camera (because the film-frame diagonal is 43mm). A 90mm lens is normal for a medium format camera, and a 150mm lens is normal for a large format camera. Although a normal lens is adequate for portrait photography (as Robert Franks proved in

Taking advantage of the distortion of a wide-angle lens, this color infrared portrait is a surreal interpretation of a cookout. (Camera—Canon; Lens—20mm; Film—Kodak EIR; Lighting—Strobe light set at one stop brighter than the ambient light)

telephoto lenses. They are therefore very useful when you find yourself in a situation where there is not much distance between you and your subject. For instance, if you are photographing fifteen people in a 15'x15' room, the wide-angle lens may be your only choice. To minimize the lens distortion in such a situation, try to keep your subjects away from the corners of the frame where the distortion will be the most significant.

At the same aperture, a wide-angle lens will give you more depth of field than a longer lens. This added depth of field can be a helpful tool in some portrait situations. For example, if you are in a situation where the need for a wide depth of field outweighs any concerns about distortion, you may want to use a wide-angle lens.

Telephoto Lenses. The standard lens for portraiture is the telephoto. There are many good reasons for this, but the most dramatic is the way this lens compresses our three-dimensional world, flattening the appearance of the foreground, middle ground, and background. This effect is the result of the increased magnification of the image and the narrower angle of view. In formal portraiture, such as wedding and corporate, using a telephoto lens will reduce visual clutter.

The flattening effect of the telephoto lens also compresses the subject. This will determine what pose you use; such as having them turn at a 45° angle or having them lower

his milestone book *The Americans*), it does not render the most flattering results.

Wide-Angle Lenses. A wide-angle lens may not flatter your subject (because of the distortion it causes), but it may be the right lens to emphasize a particular point of

view. This is often an editorial choice and may be more appropriate for portraits that illustrate a story.

There are two additional advantages to using a wide-angle lens: angle of view and depth of field. A wide-angle lens has a broader angle of view than either the normal or

Above—These photos demonstrate how a telephoto lens compresses visual planes. The photo on the left of choreographer Christy Lee was taken with a 120mm lens on a medium format camera. For the image on the right, I switched to a 300mm lens, subtly increasing the compression. This flattens out the midsection of her face and emphasizes her eyes. **Facing Page**—The client, Amanda Rogers, needed publicity photos for her acting career. I shot this on the roof of my studio using a telephoto lens with the aperture wide open to render the background completely out of focus. (Camera—Canon; Lens—200mm/f2.8; Film—Fuji Provia; Lighting—Natural; Filter—81A)

their head. You may have to try several different poses to determine the most flattering position.

Zoom Lenses. A zoom lens is great if you need a range of focal length lenses and want the convenience of having them all in one. However, it is rare that you will be switching from a 28mm to a 105mm lens in one portrait session. In fact, the more lens variables you incorporate into a portrait session the more complicated the session can become. For that reason alone it might be best to stick with one fixed focal length lens.

Another issue with the zoom lens is speed. Unless you pay in the vicinity of $1,700 for a fast zoom lens (such as a Canon EF 70–200mm f2.8L USM), you will be limited to a maximum aperture of f4.5–f5.6 (the first f-stop is the maximum aperture at the wide-angle focal length of the lens, while the second refers to the maximum aperture of the lens at the telephoto focal length). This can cause difficulties if you want to use a shallow depth of field to throw the background and foreground out of focus.

5. FILTERS FOR PORTRAITS

FILTERS HAVE A WIDE RANGE OF APPLICATIONS FOR PORTRAIT photography. They can soften the face, warm up a scene, convert the color temperature of the light, increase the contrast in a black & white image, or create a special effect. If you only buy one, purchase a UV (ultraviolet) filter to protect the front element of your lens from being scratched, and absorb UV light that can degrade the quality of the image. The following are some additional filters that are useful for portrait photography.

▼ SOFTENING FILTERS

In the old days, portrait photographers would punch a few small holes in a gauzy material, such as a stocking, and place it over the lens. This technique diffused and scattered the light striking the film, creating a softer look. This was primarily used to reduce the visibility of age lines on the subject's face. Today, manufactures produce a wide variety of glass and plastic filters to create the same effect. Examples include:

1. **Soft Focus Filter Using Concentric Rings.** Using concentric rings etched in the glass, these filters reduce the contrast of the image and create halos around the highlights. Their effect can be enhanced by opening up the aperture and reduced by closing it down. They are available in grades of 1 and 2, with the 2 having a greater effect.

2. **Diffuser Effect Filters.** This filter creates an effect similar to the concentric ring filter by using an irregular glass surface to soften wrinkles and blemishes by throwing them out of focus. Tiffen makes a Black Diffusion/FX filter that incorporates irregular black patterns that soften small details, such as blemishes and

Without filter.

With Zeiss Softar filter.

With concentric filter.

Digitally softened.

wrinkles, while leaving larger elements, like eyes, sharp.

3. **Soft Spot Filters.** The soft spot filter has a clear circular center, which maintains the sharp details of the subject in the center while softening the surrounding areas. Smearing petroleum jelly on a UV filter and keeping the center clear can also achieve this effect.

4. **Zeiss Softar Filters.** These are the most effective soft filters on the market—and the most expensive. The filter has built-in mini-diffuser lenses in the glass, which softens the contours of your subject without giving an out of focus appearance. Unlike other softening filters, the adjustment of the aperture does not change the effect.

If you shot your portrait using a digital camera or scanned your portrait into your computer, you can also soften your image digitally. Using Adobe Photoshop, you can soften a selected area using the Blur tool. Alternately, you can soften an entire image (or a selected area) with the Gaussian Blur filter. If you like, you can then use the History Brush tool to restore sharpness to any area that seems excessively out of focus.

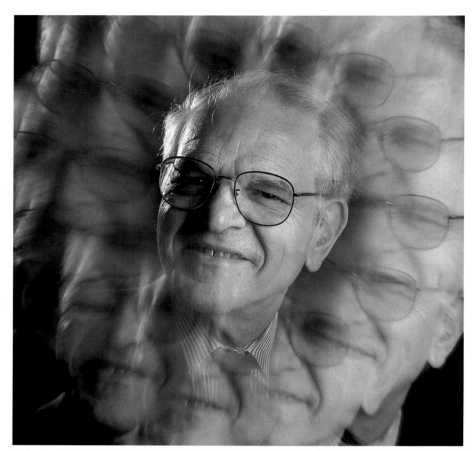

I photographed Joseph Flom of the law firm Skadden, Slate, Meagher and Flom LLP for a business magazine. The editorial concept was to illustrate the large number of lawyers that were employed by Flom's firm. I chose a Cokin 203 X13 Multi-Image filter to create the multiple effects. (Camera—Hasselblad; Lens—120mm; Film—Fuji Provia; Lighting—Strobe)

▶ SPECIAL EFFECTS FILTERS

Special effects filters can create starbursts, motion effects, double exposures, and more. These filters are not used much in portraiture, but from time to time there is an occasion to use one, as in the portrait above.

▶ COLOR CONVERSION FILTERS

The color temperature of light is measured in degrees Kelvin (°K). Daylight film is balanced for a color temperature of 5500°K; warmer (more orange) light has a lower color temperature, while cooler (more blue) light has a higher color temperature. The exact color temperature of natural light, and thus the color rendition of subjects that are lit by it, changes over the course of the day. As a result, you might want to consider using a filter that alters the way the film records the light's color temperature.

The time of the day, as the sun moves through its arc and is filtered through more or less of the Earth's atmosphere, is what dictates the color temperature of the light. In the early morning and late evening, the sun is at a low angle and light from it travels through a large amount of the atmosphere. This has the effect of filtering out many of the blue wavelengths, so the light is at its warmest at these times. Using the Kelvin scale, these times of day

measure 3400–4000°K, which gives the light an orange cast. As the sun rises, less of the blue light is filtered out and the temperature cools to about 5500°K, which gives the light a bluer cast. If the sun goes behind clouds or your subject is standing in shadow, the temperature rises and the light becomes even bluer.

The way you decide to portray your subject will determine whether or not you decide to use a color conversion filter. For instance, if you want to portray your subject as warm and friendly and the weather is overcast, you would probably want to use a warming filter to ensure that the skin tones don't look too bluish or cool. If you need to photograph your subject outside first thing in the morning and don't want an orange cast, you would use a cooling filter to create a more neutral skin tone.

The color conversion filters are of two types: warming filters and cooling filters. The 81 series (81A, 81B, and 81C) are warming filters. They are graded from A (the least warm) to C (warmest). Which one you choose will be determined by how much you want to warm your sub-

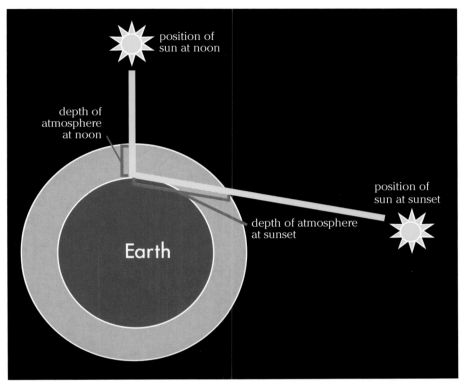

Sunsets and sunrises are reddish because the position of the sun means that the light must pass through a greater depth of atmosphere. The stronger red wavelengths can penetrate this, while the blue ones get scattered more easily.

Open shade portrait.

Open shade portrait with 81B filter.

ject. The 82 series (82A, 82B, and 82C) are cooling filters. They are also graded from A to C, with A being the least cool and C being the coolest. They will absorb the warm evening or morning light to produce more neutral skin tones.

Two other color conversion filters to consider are the 80A and B series (which are blue) and the 85 filters (which are yellow). The 80A filter eliminates the color shift when you shoot daylight film under tungsten lighting (3200°K), while the 80B filter allows you to shoot daylight film under a studio photoflood (3400°K). The 85 series filters allow you to shoot tungsten film under daylight conditions without creating a major color shift.

▶ BLACK & WHITE CONTRAST FILTERS

When shooting black & white film, you may occasionally want more tonal separation in your portrait. For example, imagine your subject has red hair and blue eyes and is wearing a green turtleneck. Without a filter, all of these colors would all have similar tones on black & white film. To make her green eyes lighter in the print, you could use a green filter to absorb red and blue light and transmit green light. This will intensify the amount of green light on the film, creating more density in the green areas and lighter green eyes in the print. Because the green filter also absorbs some of the red light from the hair, there will be less density on the negative in this area and, as a result, the hair will be darker in the print.

Color

No Filter

Yellow filter

Green filter

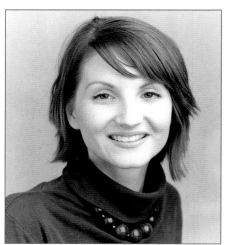
Red filter

This series of images demonstrates how black & white contrast filters separate tonal values. As you can see, the filter color transmits a higher percentage of its own color, creating more density in that area of the negative. This results in a lighter tone on the print. When you learn to use contrast filters effectively, you will be able to bring out or blend important areas of your portrait. Another reason you might choose to use contrast filters is to separate the tonal values of the subject's wardrobe from the background.

W HETHER YOU ARE PHOTOGRAPHING AN OUTDOOR portrait, using the sun as your only light source, or in the studio with expensive strobe lights, the principals of lighting remain the same. The quality of light, whether it is natural or artificial, will be either hard or soft. Which quality of light you choose will be determined by how you want your subject to appear and what mood you want to create.

▶ QUALITY OF LIGHT

Hard Lighting. Hard lighting is characterized by an abrupt falloff from highlight to shadow. Creating a strong modeling effect that accents shapes, this type of light emphasizes the form and outline of

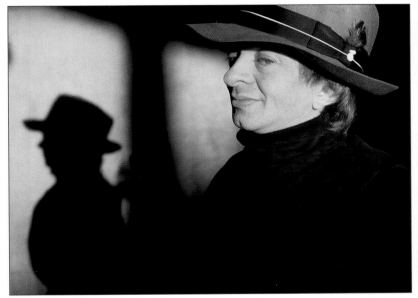

Actor Michael John Anderson came to my studio after he appeared in *Twin Peaks* as "a man from another place." In the spirit of his character, a hard light was used to create a sense of mystery. (Camera—Canon F1; Lens—35mm; Film—Fuji RDP; Lighting—Strobe for subject, natural light on backdrop)

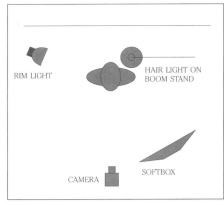

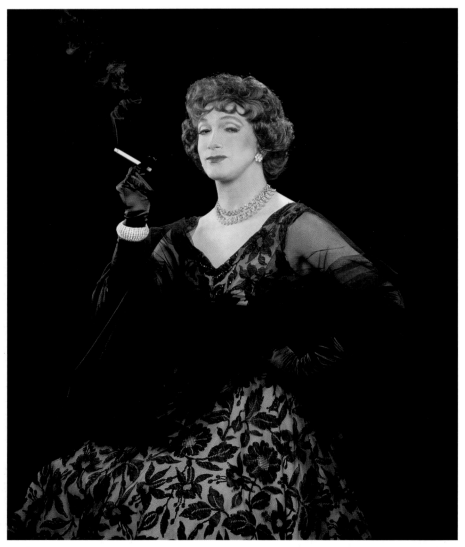

I took this photograph of the playwright/ actor Charles Busch for *New York Magazine*. The main light was a diffused 40" reflector placed to the subject's right. Two additional hard lights were used for the hair light and a rim light separated Charles from the black background. See the diagram above.

your subject. Used effectively, hard lighting brings out the model's sharp contours and, depending on the angle of the light, the textures of the fabrics he or she is wearing. Combined with the beauty of black & white film, which also emphasizes form, this can give you a winning formula for a fashion shoot.

Hard lighting has long been a popular style in portrait photography. Henry P. Horst, who launched his career as a fashion photographer in the 1930s, was a master of controlling hard lighting. This style of lighting is also typical of the glamorous images of Hollywood stars and starlets of the 1940s, created by master photographers such as George Hurrell. The ability of hard lighting to add drama and glamour to an image still appeals to contemporary photographers, so it remains a popular style.

Hard light is produced by any direct continuous or strobe light that is not diffused or modified. For maximum effect, the diameter of the light is relatively small. This results in the production of strong highlights and dark shadows. The sun (especially during the midday hours) is the most accessible and least expensive hard light source.

For better control, a spot light or Fresnel light (a focusing spot) allows you to focus the light from broad to narrow. A spot light can be a continuous light source, such as a parabolic can light, (literally a bulb in a can with no focusing mechanism), or a strobe light narrowed by the use of varied degrees of honeycomb grids, (the smaller the degree number the more narrow the light). The Fresnel (be sure to pronounce it with a silent 's') uses a Plano-convex lens that is flat on one side and curved outward on the other side to focus the light. Bringing the lens closer to the bulb broadens the light and decreases the intensity.

The quality of hard lighting emphasizes the texture of surfaces. If your subject has ruddy, blemished, skin you may want to avoid using hard lighting.

Soft Lighting. Soft lighting is characterized by a very gradual transition from highlight to shadow. In contrast to hard lighting, soft lighting tends to reveal the character of the subject. As the highlight-to-shadow transition occurs more gradually, more of the midtones are filled in and more surface detail is captured.

Although soft lighting generally uses larger light sources to wash the subject in light, it is still important to select and place your lighting units carefully. If the soft light is too close to the subject or too large, there will be no shadows cast and the subject will not be well defined.

The size of your light source should be proportional to the size of your subject. In portraiture the size of your light source would depend on whether you are photographing a head and shoulders portrait or a group portrait. For example a 42" umbrella will cover an area of 36". The spread of light would be sufficient for a head and shoulder portrait. The same rule applies for the size of the softbox.

It is important to remember that the light head, not the bottom of the umbrella or softbox, should be

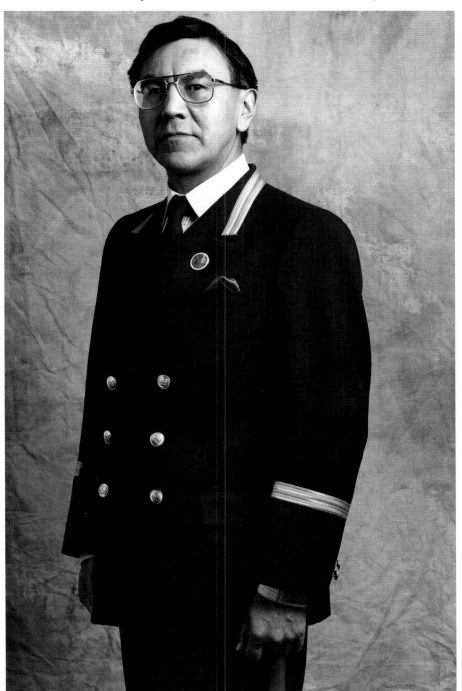

I took this photograph for the *United Nations Development Program Magazine* to record the attendees of a conference. One medium-sized softbox was placed over the strobe head to produce a soft, gentle light. Since the photographs had to be set up in the UN lobby, I used a mottled gray backdrop to isolate the subjects.

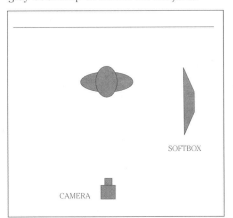

SOFTBOX

CAMERA

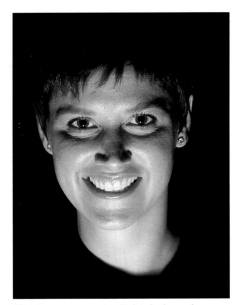

Placing your main light below the eye level of the subject creates a ghoulish look.

slightly above eye level of your subject otherwise your lighting will give off a ghoulish look as illustrated above.

The distance from the light source to your subject also affects the quality of the light. The closer the light source is placed toward your subject, the softer the light.

A good way to understand this concept is stand in front of a mirror with a flash light. Point the light at your face, holding it about 5" away from your skin. At this close distance, the light will cover most of your face, but as your extend your arm away from your face the light will progressively appear harsher.

Placing your light source further from your subject also decreases the measured brightness of the light. Therefore it is important to re-meter the light on your subject whenever the distance from the subject to light changes.

▼ LIGHT MODIFIERS

The following is a list of some of the light attachments that you can use to control the quality of the light source.

Light Reflectors. These attach to the light head to contain and direct the light source. The method of attachment will depend on the manufacturer of the light head. The standard light reflector is 8.25" in diameter and spreads the light 50°. Reflectors come in different diameters and shapes. The smaller the diameter, the more narrow and concentrated the light.

Honeycomb Grid Spots. Honeycomb grid spots are placed in front of the light source and held on by a grid reflector or an accessory holder. They are used to create soft-edged spots of light on your subject. They can be used as a hair light, background light, edge light or even as a main light. Honeycomb grids come in different sizes measured in degrees—the smaller the degree, the narrower the light.

Barndoors. Barndoors are primarily used on continuous-light units. They are mounted to the front of the light unit and are used to flag (gobo) and narrow the light source. They come with two, four, or eight leafs; the more leafs, the better the light control.

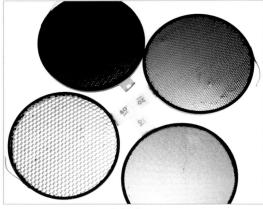

Grid Spot

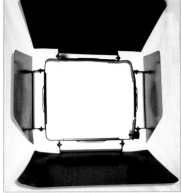

Barndoor

Snoots

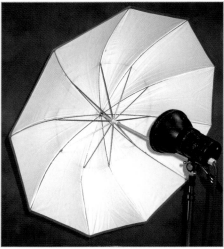

Umbrella

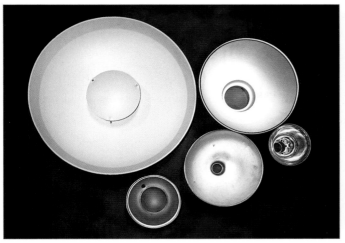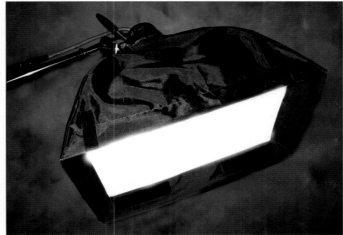

Left—Reflectors come in many styles. Clockwise from top left: 22" reflector with a deflector dish (also called a beauty dish); 16" universal sports reflector; parabolic reflector for a tungsten light; 12" flood reflector; 9" grid reflector. **Right**—A softbox.

Snoots. Snoots are placed in front of the light source to create a narrow beam of light. They are very useful when you are creating pin-point lighting on your subject.

Umbrellas. Umbrellas are used to broaden and soften a light source. They are usually attached to the light head by placing the stem of the umbrella through a hole in the housing unit of the light, or by use of a bracket. The material and size of the umbrella will determine the quality of the light and how the light is directed. The standard headshot umbrella has a 42" diameter. The four types of umbrellas are white, silver, translucent, and zebra (white and silver or gold interior).

Softbox. Softboxes mount to the light head by means of a bracket or speed ring. The light element points toward the front of the softbox and is diffused as it bounces around the white interior and goes through a baffle and out the front panel.

The front translucent panel can either be rectangular or oval. You can also customize it to whatever shape you want by masking it with black tape. I have even used a grid pattern of tape to create the look of a paned window on the highlights in my subject's eyes. The interior of the softbox can either be all white or have panels of gold or silver.

Unlike the umbrellas, softboxes provide even lighting from top-to-bottom and side-to-side. The other distinctive quality of softboxes (compared to the umbrellas) is that their light falls off very quickly (similar to window light) and has a warmer look due to the diffusion material that the light passes through.

Softboxes come in several sizes, starting at 12"x16"x9" for on-camera flashes, to 54"x72"x32" for off-camera units used in group photos. The thing to remember is that the size of the light source should be proportional to the size of the subject.

Parabolic Reflector Cans. Parabolic reflector cans (commonly called "PAR cans," or simply "cans") are non-focusable instruments. They consist of a metal cylinder with a sealed-beam parabolic reflector lamp at one end. These lamps are similar to those used in many automobiles as headlights. They throw an unfocused beam, shaped by the type of lamp inside. The most common types are: very narrow spot (VNSP, or "vee-nisp"), narrow spot (NSP, or "nisp"), medium flood (MFL, or "miffle"), and wide flood (WFL, or "wiffle"). In addition to the type of lamp, parabolics reflector cans come in several sizes, denoted by a number (typically either 16, 38, 46, 56, or 64). The instrument size and light produced increase with this number.

▶ LIGHT POSITIONS

In addition to being hard or soft, lights are also described in terms of their position and function in relation to the subject. All images will have a main light (see below), but many will also incorporate other light sources to enhance the main light or accent a particular feature of the subject or scene.

Main Light. The primary source of light on your subject is called the main light. Where you direct this light shapes your portrait and creates the shadows on the face that reveal its shape. This light tends to be placed at an angle to the subject, but can also be on axis with the lens for the shadowless frontal light often used in fashion photography.

Fill Light. If you like, you can add a secondary source of light (or a reflector to bounce light) on the side of the subject that is opposite the main light. Called a fill light, this light source brightens the shadows on the subject, reducing the contrast between the highlight and the shadow areas of the face.

Background Light. One or more lights can also be added behind the subject to illuminate the background. This light also increases the sense of depth by providing tonal separation between the subject and the background.

Hair Light. Added above the subject, the hair light adds highlights to a subject's hair and also helps to create separation between the subject and the background.

Kicker Light. Also called accent lights, these units are added to illuminate any area of the subject or scene where a highlight or additional shaping is desired.

▼ LIGHTING PATTERNS

There are many ways to sculpt your subject with light. The desired effect is often decided once you have studied your subject's features and have determined the final use of the photograph. Evaluating whether your subject has a round face, high cheekbones, or a large nose will determine the placement of the lights. Other considerations, such as the client's intended use for the images (be it commercial, theatrical, or personal) will also play a factor in how you set up your lights.

The four lighting setups below demonstrate how the placement of lights can alter the shape and feel of the portrait. All the set-ups use a 1:2 lighting ratio to compensate for the narrow latitude of color transparency film. If you want more dramatic results, use a higher lighting ratio—especially if you are shooting black & white film. Because the lighting ratio is low, you will not be able to see the described diamond and butterfly shapes in the examples, but you *will* see them when you set up

the lighting patterns yourself. The final effect of the light remains the same.

Rembrandt Lighting. This type of lighting works well with full faces and will emphasizes the texture of the skin and material. It is one of the more common setups and can have a dramatic effect. When setting up the main light, you should look for a diamond shape to form below the farthest eye (here, the right eye), it should be longer than the nose but not wider than the eye. It is a good idea to turn off the fill light to see the shape more clearly.

Loop Lighting. The setup for loop lighting is similar to the one used for Rembrandt light. The major change is that the main light is raised and moved closer to the camera. The effect of this light will broaden a narrow face and reduce the texture. When setting up the main light the "loop" from the nose area should not touch the shadow area on the side of the face.

Split Lighting. Split lighting creates a more slender and narrow appearance of the face. It also brings out a lot of texture. The main light should illuminate half the face and three-quarters of the forehead. The use of gobos will help prevent stray light from falling onto the other side of the face and background. The main light should be lower than the position used in Rembrandt lighting, and the fill should be raised up higher while remaining opposite the main light.

Tips Continuous lighting enables the photographer to observe the changes of light as they happen. Because of this, photographing with continuous lighting is a great way to learn how changes in light direction and distance alter the form of your subject. Continuous lighting systems are less expensive than strobe lighting. Flood lights, desk lamps, even car headlights can be used as a main light source. There is no need to purchase a special strobe meter since your in-camera meter will measure continuous light.

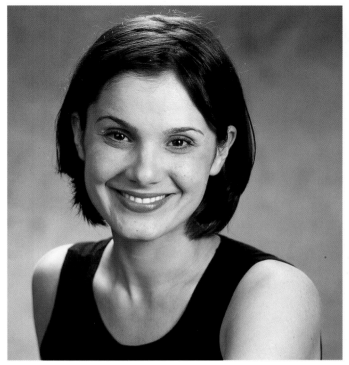

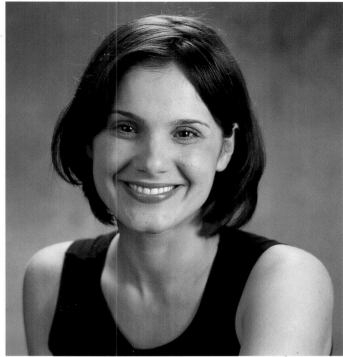

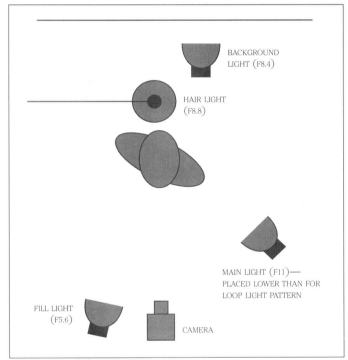

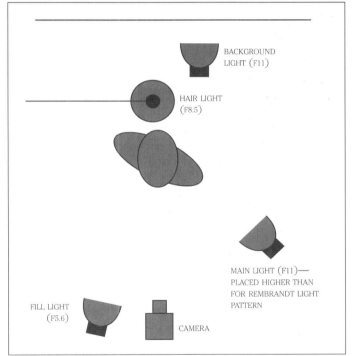

Rembrandt lighting emphasizes texture and works better for full faces than narrow faces. On the shadow side of the face, a diamond-shaped highlight should be formed under the eye. This should be as long as the nose and not wider than the eye. Your main light should be lower than in the loop lighting setup (see next image) and moved closer toward the background. The fill light should be even with the camera and up higher, while remaining opposite the main light.

Loop lighting helps to broaden a narrow face. The loop-shaped shadow under the nose should not touch the shadow area at the side of the face. Your main light should be placed lower than in the Paramount setup (see next page) and moved in closer to the background. The fill light should be even with the camera and placed higher while remaining opposite the main light.

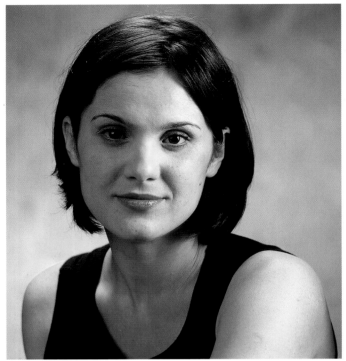

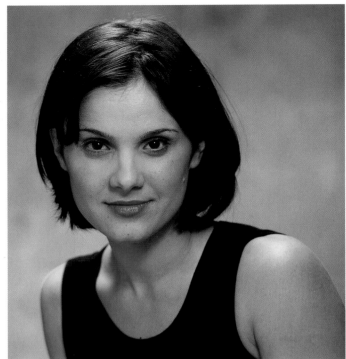

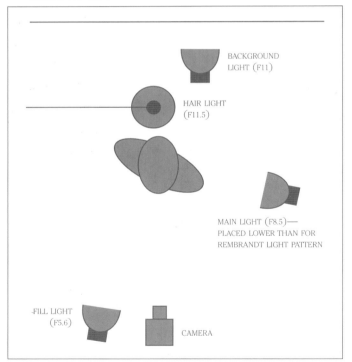

BACKGROUND LIGHT (F11)

HAIR LIGHT (F11.5)

MAIN LIGHT (F8.5)— PLACED LOWER THAN FOR REMBRANDT LIGHT PATTERN

FILL LIGHT (F5.6)

CAMERA

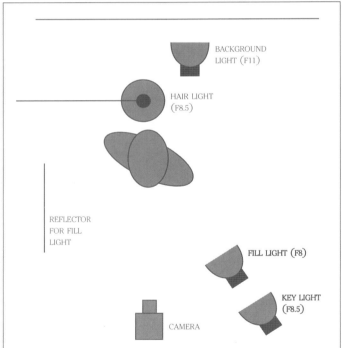

BACKGROUND LIGHT (F11)

HAIR LIGHT (F8.5)

REFLECTOR FOR FILL LIGHT

FILL LIGHT (F8)

KEY LIGHT (F8.5)

CAMERA

Split lighting brings out a lot of texture. It slenderizes and narrows faces. In this setup, the lights should be positioned so that the shadows just fall off the far eye; half of the face and three-quarters of the forehead should be in highlight. Gobos can be useful for controlling stray light in this setup. The fill light should be placed even with the main light and high up. The key light should be lower than in the Rembrandt lighting setup (see previous page).

Paramount lighting helps to flatten features and smooth textures while giving a broad look to narrow faces. This type of lighting also emphasized cheekbones. When properly executed, this lighting results in the appearance of a butterfly-shaped shadow under the nose. This should end halfway between the lip and nose. Your main light should be at a 45° angle to the camera and relatively high. The fill light should be higher and behind the main light.

Paramount Lighting. Made famous by Paramount Studios in the 1930s, this is a classic style that flattens features, reduces textures, emphasizes cheekbones, and gives a broad look to narrow faces. In this lighting configuration, the fill light is brought behind the main light and a reflector is used to fill in the shadow side of the face. When setting up the main light, turn off the fill light and look for a butterfly-shaped shadow beneath the nose. The shadow should end halfway between the nose and the upper lip. The main light should be at a 45° angle from the camera and placed slightly above the eyes of your subject pointing down. You may want to use a smaller modifier on your light head to create a sharper light.

▼ NATURAL LIGHT

When you are shooting portraits for yourself or your family and are working on your own time in your own space, the sun is one your best sources of illumination. As you begin working with sunlight, however, keep in mind the two basic qualities of light: hard and soft. The quality of the light you choose will depend on your subject and the intent of the portrait. For instance, hard light will exaggerate features on the face by creating deep shadows. Soft light will reduce shadows and, in turn, soften facial features. As a result, the quality of light you choose can help you either to accentuate or disguise your subject's features.

Controlling the Light. Controlling natural light is all about observation, metering, and common sense. While you can't actually control the sun, you can redirect it by blocking, shading, or reflecting it to shape the light falling on you subject. The following is a breakdown of the fundamentals of controlling the quality of natural light. These same principals also apply to using artificial light.

You'll need a few basic materials to get started—these can be purchased at any art supply store. Begin by purchasing 30"x40" two-ply white, black, silver, and gold cards (or foam-core board), and some gaffer's tape. These boards will act as your light reflectors and gobos (gobo is short for "go between" and refers to a device placed between the subject and a light source to block some or all of the light; these can also be called flags). The boards can also

double as a place to rest your cameras when you are shooting outdoors. To make your cards more mobile, score and quarter them, taping the seams, so they fold down to a manageable size of 15"x20".

If you have a bigger budget you may want to consider purchasing flexible discs and light panels made of fabric. These are manufactured by several companies (Photoflex, Westcott, Flexfill , etc.) and come in all shapes, colors, and sizes. They also break down quickly to a manageable size.

Direct Sunlight. If your objective is to bring out the texture and shape of your subject's face in order to emphasize particular physical characteristics, direct light may be your best choice. Direct light also produces the most contrast and, in turn, may create unwanted shadows. The time of day plays a major factor

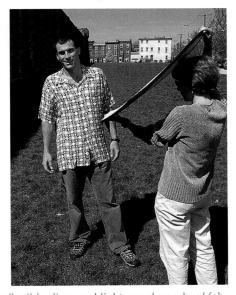

Left—You may want to consider purchasing flexible discs and light panels made of fabric. These are manufactured by several companies (Photoflex, Westcott, Flexfill , etc.) and come in all shapes, colors, and sizes. **Right**—It is always helpful to have an extra set of hands to hold a reflector. If you go alone, bring an extra light stand, two A-clamps and a sandbag (or other weight) to keep the stand from falling over in a sudden wind.

when using direct light. The early morning and late evening will produce a softer quality of light than midday, since the light at these hours is diffused through more of the earth's atmosphere.

Remember to consider your subject's needs, as well. Looking into the direct light can be difficult, especially if your subject has light colored eyes. If you find your subject is constantly squinting because of the direct light, have them close their eyes until you are ready to shoot, give them a count to three, and then ask them to open their eyes slowly. If this doesn't work, consider shooting them under open shade or with reflected sunlight.

Open Shade. When the sun's direct illumination is diffused or blocked (by clouds, trees, buildings, etc.) it is called open shade. Open shade is characterized by low-contrast, flatter light that produces a softer effect that is often more flattering than direct sun. You can also create your own open-shade lighting situation by placing a gobo or flag between the direct light and your subject (often above the subject).

When shooting color film under open shade, you'll find that the color temperature of the light is higher than in direct sun, producing a cooler light with a bluish hue. If you want the color of your portrait to appear as if it were shot under direct light—or even late evening light—use a warming filter (such as an 81A or 81B) over your camera's lens.

Reflected Light. Another way to soften direct light is to use a reflector to redirect the sunlight onto your subject and fill in the shadows. The type of reflective card you use determines the brightness and quality of the redirected light.

The most common reflectors are white, silver, or gold. The white reflector produces a neutral, soft illumination. The silver and gold are more reflective and produce a brighter harder light. When shooting color film, gold reflectors also serve to warm up the color of your subject.

You can also vary the effects you achieve by adjusting the size and surface texture of the reflector. A large reflector will spread the light more evenly and more effectively reduce the contrast. Silver and gold reflectors with a bubbled textured surface will also produce a softer light.

Open shade is characterized by low-contrast, flatter light that produces a softer effect that is often more flattering than direct sun.

Portrait in direct sun with no fill.

Portrait with white fill card.

Portrait with silver fill card.

Portrait with gold fill card.

Tips **Bouncing light off a silver or gold reflector can be hard on your subject's eyes. To minimize this, have your subject close their eyes, then open them slowly when you are ready to take the photo.**

You can even make your own reflectors by taping foil (aluminum or any other color) to a card, or by using a mirror, which will reduce the softening effect and maintain a higher contrast.

Fill-in Flash. If your subject is backlit and/or your objective is to balance the background light with the light on your subject, a fill-in flash is the best way to achieve your goal. This technique may appear intimidating at first attempt but becomes easier with experience.

The first step is to determine light value of the background. Meter the background with your camera's built-in meter (the reflective meter). This exposure reading will determine how bright your subject needs to be in order to balance with the background.

If your reading of the background is f11 at $^1/_{60}$ second, then you would then set your flash to illuminate your subject at between f8 and f11, depending on how natural you want the light to appear. The larger opening of f8 to f8.5 would give your portrait a more natural appearance.

▶ HOT LIGHTS

Continuous light sources, called hot lights, can be useful for indoor portraits that need auxiliary lighting to either compensate for the lack of natural light or complement it. There are many variations of continuous lighting configurations. The system you choose should reflect the type of work you intend to do, while staying within your budget.

One important consideration when using hot lights is color balance. If you want to use daylight-balanced color film, you'll need to fit your continuous lights (with the exception on HMI lights, as noted below) with an 85B filter or use an 80A color-conversion filter on your camera to ensure accurate color reproduction. Alternately, you can shoot your images on tungsten-balanced film.

Photofloods. An easy and inexpensive solution is to use photofloods. Photofloods have a tungsten

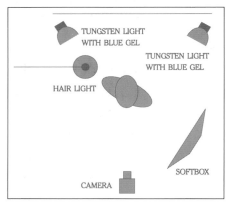

I shot this portrait of actress Anna Marie Wieder for an article about Hollywood stand-ins. Although you see hot lights in the image, the photograph was actually taken using strobe lighting. To balance the hot lights in the scene to the strobe and my daylight-balanced film, I fitted them with 80A gels. I also used a purple gel on the hair light to give the impression of a movie light. (Camera—Hasselblad; Lens—50mm; Film—Fujichrome RDP; Lighting—Strobe)

filament that produces a light color temperature of 3200°K–3400°K.

Quartz-Halogen Bulbs. A more expensive but longer lasting continuous light is the quartz-halogen bulb. The quartz-halogen lights, geared more toward the professional, allow for lighting accessories such as barndoors, scrims, gel frames, reflectors, and other light controlling devices to be added.

HMI Lights. If you have a larger budget, you may want to consider HMI lights. HMI lights are daylight balanced at 5600°K making it easy to shoot daylight color film without the inconvenience of having to use color correction gels over your light source or camera lens.

Advantages/Disadvantages. There are a couple of advantages to using continuous light. First, you can

immediately see how the light shapes your subject as you move it around the subject and add reflectors, scrims, and other accessories. Second, you can use your camera's built-in light meter to measure the light reflected by your subject. For a more accurate meter reading, have your subject hold a gray card in front of their face and measure the light reflectance.

There are also disadvantages associated with using continuous lighting. First, the lights generate a lot of heat (although more expensive units feature an internal fan to help keep the light head cool). When using them, be very careful not to touch the light head when it is on and wait about ten minutes after you have turned it off to let it cool down. Hot lights also draw a lot of power; if you are using more than one, plugging them into different outlets can help avoid blown circuits.

▶ ON-CAMERA FLASH
Commercial portrait photography is creation on demand; you do not have the luxury of waiting for the right light. Your subject usually has a limited amount of time and, unless you are working out of your studio, you will be shooting in unfamiliar surroundings. This is when auxiliary lighting becomes an essential tool for the photographer.

Advantages/Disadvantages. Flash photography is one of the most intimidating aspects of professional photography. Unlike continuous light

the effects of flash on your subject cannot immediately be seen and cannot be measured by your camera's internal light meter. There are many types of flash systems and your personal needs will determine the flash system that best suits you. Once you master the basics of flash photography you will find it is one of the most useful tools in portraiture. Unlike continuous lights, flash units do not get hot, they are balanced for daylight film, and they produce a lot of light in a short burst (about $^1/_{2000}$ second). The applications are only limited by your knowledge and imagination.

History. The first successful flash can be traced back to Germany in 1887. At that time, the burst of light was created by use of a highly explosive mixture of powdered magnesium, potassium chlorate, and antimony sulphide. Its primary objective was to illuminate a dimly lit scene and freeze the action. Although the flash has become a lot safer and more controllable over time, its primary objective has stayed the same: to illuminate.

Dr. Harold Edgerton invented the next evolution in flash photography in 1931. His particular interest was

capturing on film objects that were moving at speeds beyond the ability of the human eye to see in detail. This spurred him on to experiment with ways to synchronize strobe flashes to fast moving objects. His development of the Stroboscope revolutionized the application of the flash for freezing high-speed movement. His photographs can now be found on museums walls around the world.

Sync Speed. The shutter speed needed to sync your flash depends on whether your camera has a focal-plane (or curtain) shutter (found in the camera body), or a leaf shutter (found in the lens). Leaf shutters allow you to sync at the fastest available shutter speed, up to $^1/_{500}$ second. Most curtain shutters in 35mm cameras allow you to sync your flash up to $^1/_{125}$ second; Nikon and Canon, however, manufacture some models that sync at up to $^1/_{250}$ second. If you sync your flash higher than the recommend shutter speed, the flash will only illuminate part of your frame. This occurs because the distance between the shutter curtains as they move across the film plane is so narrow, and the duration of the flash is so short, that the light from the flash

On a camera with a focal plane shutter, the exposure begins when the first curtain moves across the film plane and lets light hit the film. It ends when the second curtain follows the first and closes off light. The flash sync speed is the shortest shutter speed where the space between the moving curtains is the full width of the frame.

Because the flash fires only when all the blades are fully retracted, cameras with leaf shutters can sync with the flash at any shutter speed.

doesn't have time to illuminate the entire frame. This fact makes it vital that you know the maximum shutter-speed setting for your flash.

On-Camera Flash. The easiest and least expensive way to become familiar with using flash lighting is to purchase an on-camera flash unit, such as those produced by Vivitar, Sunpack, or Metz. There are also

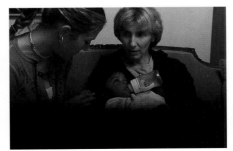

When the flash and shutter do not synchronize correctly, the film frame will be only partially exposed, as seen in the above images.

I photographed three generations of the Weihs family for my book *Fathers and Sons* (Abbeville Press, 1989). Kurt, the father, was a well know advertising art director for George Lois, so it made sense that he "paint" the light with the pen light in his right hand. Tommy, Kurt's son, was my friend and photography mentor, hence the camera. Kristian, Tommy's son, struck an appropriate pre-teen pose. (Camera—Hasselblad; Lens—150mm; Film—Kodak Ektachrome; Lighting—Strobe and tungsten [from the pen light])

camera manufacturers who manufacture their own dedicated on-camera flash units. These are more expensive, but they take a lot of the guesswork out of calculating the correct exposure. If you're not lucky enough to own a fully automatic on-camera flash, here is a simple way to measure the light output and calculate the f-stop.

1. Set your ISO on your on-camera flash unit.
2. Focus on your subject and look at the distance scale on your lens barrel to determine the distance from your film plane to your subject.
3. Check the guide number on your flash; it will indicate the correct f-stop.

Guide numbers reflect the light output of the flash. The more powerful the flash, the greater its range will be. Here are some simple calculations for working with guide numbers:

Guide Number (GN) =
f-stop x flash-to-subject distance

Aperture (f-stop) =
GN ÷ distance to subject

Maximum flash range =
GN ÷ largest lens opening

On-Camera Flash Used Off Camera. Most on-camera flashes come with an auxiliary cord that allows you to take the flash off the camera and either handhold or mount the flash on an extension bracket away from the camera lens. This can be extremely helpful in portrait photography.

To create a more flattering light for your subject it is best to keep the main light off and away from the camera lens. If you have ever shot a color portrait with a point-and-shoot camera that has a built-in flash, you have experienced "red eye." This is one result from the flash being too close to the lens.

You can also use multiple off-camera flash units and synchronize them with a slave unit so they will all trigger simultaneously.

�? STROBE LIGHTING

On-camera flash units can handle many situations but they do have their limits. One significant drawback is that you have less control over the quality of light being emitted. The strobe light, with all its accessories and its ability to exercise pinpoint control over the light output, gives you more options and control in a portrait session.

How it Works. The light emitted from a strobe head is created by an electrical charge that runs through a capacitor. This charge ignites a tube filled with xenon gas. When the strobe is fired, a high voltage charge (several thousand volts) it is discharged through a transformer,

I photographed the above images with a medium format camera set to f16 at ¹/₂₅₀ second. The strobe light froze Delia's hair as she vigorously shook her head. One medium softbox was used as the main light and a white reflector provided fill. Two direct strobe lights were used to illuminate the background.

These portraits illustrate the creative control you can exercise when photographing portraits with strobe light. In the first image (left), direct strobe light was used with a 40" reflector. In the second image (center), the light was bounced back onto the subject out of an umbrella. For the final portrait (right), the light was directed at the subject through a light box for a softer effect.

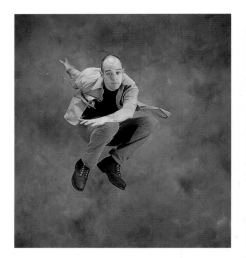

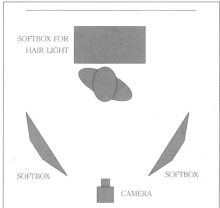

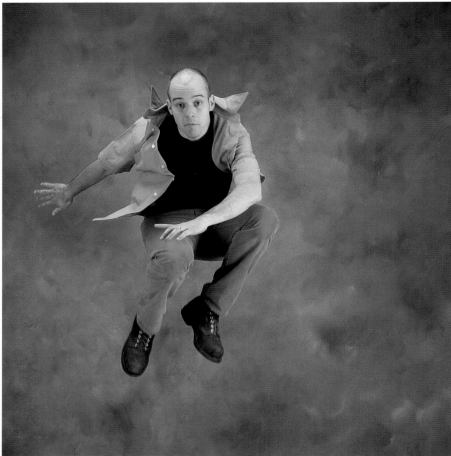

Originally developed to help film record movement that the naked eye could not detect, here the strobe was used to suspend Matt in midair.

which causes the gas to ionize, making it conductive. The ionized gas is then discharged by the capacitor, emitting a burst of light through the xenon gas tube that is commonly known as a flash.

You don't need to know physics to use a strobe light, but you should make note of the high voltage needed to create this effect. Today's strobe lights have many safeguards to prevent fatal electrical shock, but nonetheless it is imperative that you use common sense when working with these high-voltage units.

Practical Example. The portraits shown at the top of page 52 illustrate how you can control the quality of strobe light.

I illuminated the portrait on the left with one direct strobe light using a 40" reflector. Notice the quick fall-off of the light and how it produces a shadow area with little or no detail.

For the second image, I fitted the strobe with an umbrella to broaden the spread of illumination, and turned it away from the subject. The strobe then fired into the umbrella, which bounced the light back onto the subject. As a result, the light wraps more around the subject's face, creating more detail in the shadow area.

I lit the third portrait with a softbox. The strobe head was directed at the subject but both a baffle inside the light box and a translucent material on the face of the softbox diffused the light. The quality of the light produced is much softer than the umbrella and more flattering to the subject.

Creating self-portraits will help you get to know yourself and give you an idea of what your subjects feel when you turn your camera on them. I took advantage of the LCD screen to compose this digital self portrait. (Camera—Canon PowerShot G3; Zoom Lens—7.2–28.8mm; Digital Capture; Lighting—Tungsten)

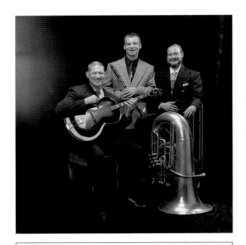

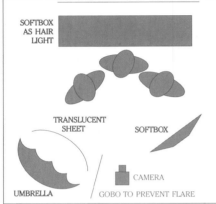

SOFTBOX
AS HAIR
LIGHT

TRANSLUCENT
SHEET SOFTBOX

CAMERA

UMBRELLA GOBO TO PREVENT FLARE

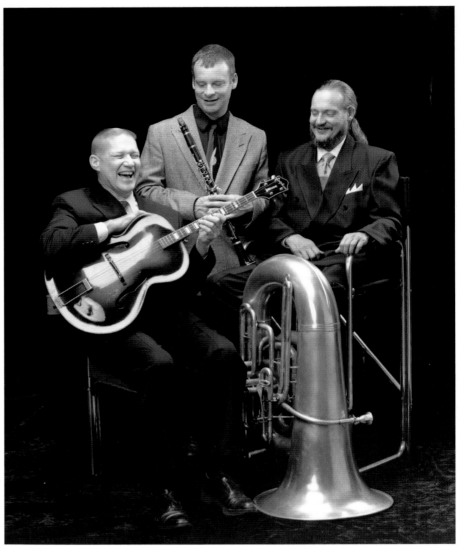

The band Hot House needed publicity photos and images for their latest CD. The session would have been a disaster, though, if I hadn't noticed that the light from a fill light was striking the front lens element and causing lens flare. The image on the left shows what this looked like. I used a black gobo between the light source and the lens to solve the problem. The result is the image seen on the right. (Camera—Hasselblad; Lens—150mm; Film—Kodak Plus-X; Lighting—Strobe)

▶ LENS FLARE

Lens flare occurs when there is strong light, such as the sun or a strobe, striking the front lens element. The flare degrades the quality of the image by partially fogging the film. When you shoot a portrait—especially situations with a strong backlight—check the front lens element for lens flare. To get rid of lens flare, either place your hand or piece of black paper between the lens and the light source, or use a lens shade.

▶ STORING, TRAVELLING WITH, AND SETTING UP YOUR LIGHTS

Cases. Camera and lighting cases come in all shapes and sizes. If you expect to do a lot of traveling to create location portraits, consider purchasing lightweight cases for your equipment. Manufactures like Lowe-Pro, Lightware, and Domke/Tiffen all make soft-sided cases out of durable, water-resistant material. They are lined with an insulative hard plastic that protects your gear. If you intend to do most of your work in a studio, you may want to purchase hard cases, such as those made by Haliburtin. It is important to protect your expensive equipment, so purchase wisely.

Stands. Light stands come in all shapes and sizes, and some manufacturers include light stands in their lighting packages. For the most part, these are sufficient for getting started. Once again, you need to consider whether you will be shooting in a studio or on location.

If location portraiture is your goal, think about purchasing light-

weight durable stands such as Monfrotto (distributed by Bogen Photo Corporation). In addition to being lightweight, Giotto light stands (distributed by HP Marketing) use air-cushioned columns to prevent the light from crashing down when you loosen the wing nut.

In the studio you may want to consider the heavier Matthews C+ stands. These are very heavy duty and have a detachable turtle base (an adjustable three-legged base) for extra stability.

If you are on budget you can create your own stands by using cement to secure a 6' long, 2" diameter pipe in a heavy-duty pail. Purchase a Bogen Super Clamp with a standard stud and you're all set—for about $35, you have a 6' studio stand that takes up little floor space. In fact if you are clever and familiar with your local hardware store, you can create many other studio devices for a fraction of what you would spend to purchase commercially manufactured equipment from a camera store.

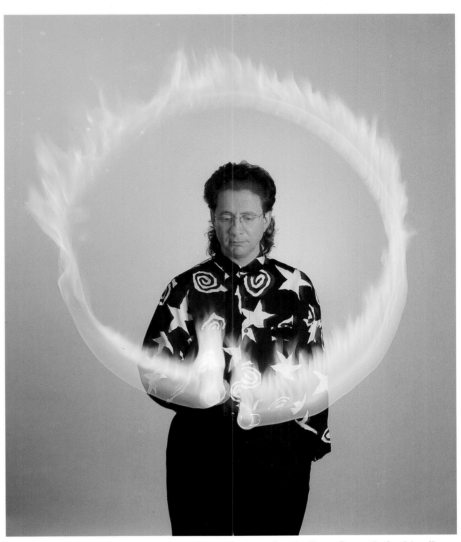

When GRP Records hired me to create an image of artist Dave Samuels for his album *Del Sol*, we thought it would be fun to try a pyrotechnic experiment. Although this image was not the one that was chosen for publication, the experience was worth it. I shot this on medium format at f8 at 4 seconds. A strobe light with a bank was placed on the right and a floor stand with a strobe was placed behind the subject to illuminate the orange background.

7. METERS AND METERING

*O*FTEN OVERLOOKED AND UNDERAPPRECIATED, THE light meter is the key to consistent results. Whether it is the meter built into your camera or hand-held model, an accurate meter is the first step to achieving a well-exposed negative or transparency. Of course, having an accurate light meter is only part of the story. Understanding both the functions and limitations of your light meter will give you more predictable results and a good night's rest.

▶ THE REFLECTED-LIGHT METER

With the exception of older SLRs and rangefinder cameras, which may not contain an internal light meter at all, 35mm SLR cameras

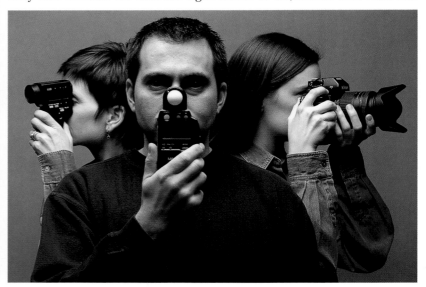

This photo illustrates three types of light meters. Annette (left) is measuring a 1° spot of light reflecting off a surface with a spot meter, Anthony (center) is measuring strobe/ambient light falling onto him with an incident/flash meter, and Janette (right) is measuring her average light reading with her camera's internal reflective meter.

I created this silhouette of Bill Cosby by metering the strong backlighting and not adjusting for the light on Cosby's face. Unless you are photographing a portrait of a well-known profile, be sure to meter off your subject's face. (Camera—Canon F-1; Lens—85mm; Film—Fuji RDP; Lighting—Tungsten)

contain a built-in meter for measuring reflected light (light bounced off the subject). This meter provides an exposure reading that is based on about 30% of the image at the center of the frame and the "average" brightness of the highlights and the shadows (many of the more advanced cameras give you the option to control the size and part of the frame measured by the meter, but all reflected-light meters provide an "averaged" reading for the metered area).

The exposure the meter suggests is correct if you want to render the scene or subject with an "average"

tonality of 18% gray. In many circumstances, this gives you an accurate reading. However, there are many common photographic situations where the exposure your meter suggests will not provide the result you intend. For example, a snow drift rendered as 18% gray would look very muddy; conversely, a black cat rendered at 18% gray would look rather washed out. The following is a list of lighting situations where you will need to make adjustments to achieve a properly exposed negative or transparency.

Backlighting. When you set up a portrait with the main light behind

your subject, you are using backlighting. The reflective meter in your camera will give you an exposure reading that averages the highlight (behind your subject), and the shadow (your subject's face) to 18% gray.

If you use the exposure setting suggested by the meter, your portrait will become a silhouette. The reason is simple: if the backlight (the highlight) reads f16 at $1/60$ second, and your subject's face (the shadow) reads f4 at $1/60$ second, the reflected-light meter will average the two readings and indicate that the correct exposure is f8 at $1/60$ second. As a result, your subject's face will actual-

Left—The first image was metered through the camera. The strong backlight overpowered the reflected light on my subject's faces. As a result, the portrait is underexposed. **Right**—To adjust for the underexposure, I filled the frame with my subjects' faces, metered the reflected light, then walked back to the shooting position. I used my left hand to shield my lens from the sun and prevent flare.

ly be two stops underexposed, rendering it as a silhouette.

There are several ways for you to correct for this miscalculation on the part of the meter.

1. Move closer to your subject and meter off their face so you get a correct reading for the important part of the image.
2. Place your hand in front of the lens and meter off it. For this to work, your hand and the subject must be in the same lighting, so this works best in natural-light situations.
3. For a more accurate reading, place a gray card in the same lighting as the subject (you can have the subject hold it up) and take a reading.

Highly Reflective Surfaces. In some situations, the dominant area of the photograph is highly reflective—such as snow-covered mountains or a white sandy beach. Because the reflective meter in your camera provides a reading designed to render the scene as 18% gray, it will read the large amount of bright highlight and small amount of shadow and suggest a shutter speed and aperture combination that will average the scene to 18% gray. The result will be an underexposed image. As in the backlighting scenario presented above, you will need to compensate for this underexposure by opening up your aperture one to two stops, or slowing down your shutter speed by the same amount. You could also take a closer reading of your subject, your hand, or a gray card.

Non-Reflective Surfaces. The same principle applies if the predominate area of the frame is non-reflective (very dark). Non-reflective surfaces absorb a lot of light, so your camera meter will overexpose the image up to one stop. If you are shooting black & white film, this means that your shadow area will

Left—The first image was shot without any exposure compensation for the very reflective scene. The result is an underexposed print. **Right**—To compensate for the underexposure, I opened up two stops.

Left—This family portrait was taken without any exposure compensation for the predominantly non-reflective surfaces. The result is a low-contrast image. **Right**—By closing down one stop from the meter reading, I achieved a fuller range of tones.

Left—The first image was shot one stop over the prescribed meter reading (f5.6 at $^{1}/_{125}$ second). **Center—** This image was shot at the prescribed meter reading (f8 at $^{1}/_{125}$ second). **Right—** The third image was shot one stop under the prescribed meter reading (f11 at $^{1}/_{125}$ second).

appear gray in the print. The correction is to close down your aperture or speed up your shutter by one stop.

Bracketing. When in doubt, it's a good idea to bracket your exposure. Bracketing means that you intentionally take extra shots that are over and/or under what your meter indicates is the accurate exposure. If you were shooting a portrait with strong backlighting, the scenario might go as follows. Your meter indicates that you should expose your subject at f11 at $^{1}/_{60}$ second. You now know that if you follow your meter reading

your subject will be underexposed. Therefore, to bracket your exposure you would shoot f8 at a $^{1}/_{60}$ second (one-stop overexposure), f5.6 at $^{1}/_{60}$ second (two-stop overexposure), and f4 at $^{1}/_{60}$ second (three-stop overexposure).

▶ THE SPOT METER

The spot meter also measures reflected light. It is unique, however, because it can measure an area as small as 0.5% of the frame (rather than the 30% area read by normal meters). This precise measurement allows the photographer to "place"

their exposure, ensuring that important areas of the image are rendered properly. Primarily used in landscape photography because of its ability to zoom in on small areas of highlights and shadows, spot meters can also be useful in portrait photography.

Imagine you are photographing a speaker or an entertainer and spotlights are the primary light source of the scene. In this instance, using a spot meter will allow you to zoom in on the subject's face for a more accurate light reading. If you used your camera's built-in meter (unless your camera has a built-in spot meter), there would be a good chance that the overall light reading would result in an overexposed image.

▶ THE INCIDENT-LIGHT METER

Unlike the reflected-light meter, which measures light *reflected off* surfaces, the incident-light meter measures the light *falling onto* sur-

Tips To gain even greater control over the creation of your negative when using a reflected-light meter, you might want to read up on the Zone System. This is an exposure system created by Ansel Adams and Fred Archer to assist photographers with pre-visualizing their images in order to consistently create properly exposed negatives. If you have ever printed your own images from negatives, you will agree that it is much easier to print from a good negative than an under- or overexposed one. The Zone System can help you create negatives that allow you to express your creative vision and make your job as a printer much easier.

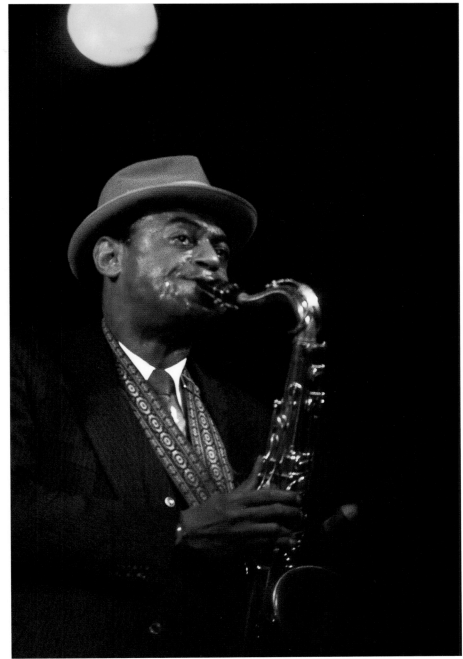

Performance photography can be very tricky to meter because of all the specular lighting. I used my spot meter to measure the light off Archie Shepp's face to make sure I properly exposed this difficult light situation. (Camera—Canon; Lens—200mm; Film—Fujichrome 1600)

THE FLASH METER

The above meters all measure continuous light values. The flash meter, on the other hand, measures the brief burst of light that is emitted from a strobe light. The flash meter, like the incident meter, measures light falling on the subject and therefore the light sensor should be pointed toward the camera or light source.

METERS IN USE

General Tips. The following are some general tips to keep in mind when using light meters.

1. Be sure to match the ISO of your meter with your film speed.
2. Calibrate your meter with another meter that is reliable.
3. Always carry a replacement battery for your meter. Most meters require one AA battery.
4. Make sure your meter is in the right mode. An icon usually denotes the modes for light meters. The icon for an ambient reading is generally a sun, for the flash it is generally a lightening bolt. If you need to plug the sync cord into the light meter to get a reading from the strobe, the icon is generally a lightening bolt with the letter "C".
5. Some meters have a control that will read for the shadows (S) and highlights (H) and exposure values (EV).

faces (i.e. the light before it hits the subject or scene). Therefore, the light sensor on the meter should be pointed toward either the camera or the light source. When you use an incident light meter, the reflectivity of the subject does not matter, since you are measuring the light before it even hits the subject. As a result, you will not need to compensate for reflected light variables. This type of meter is very useful in the studio, where you have complete control of the light source(s).

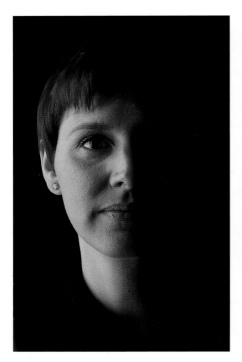

Left—I shot this at a lighting ratio of 8:1. The highlight on the left side of the face was metered at f11 at $^1/_{125}$ second, and the shadow was metered at f2.8. The transparency film I used has a short latitude and therefore there is little detail in the shadow. **Center**—I added a fill light for the second photo and the lighting ratio changed to 2:1. The highlight on the left side of the face stayed at f11 at $^1/_{125}$ second, but the shadow side increased in brightness to f8 at $^1/_{125}$ second. **Right**—I added a hair light to the third photo to create a separation between the model and the background. The hair light measured f16 at $^1/_{125}$ second. (Camera—Hasselblad; Lens—150mm; Film—Kodak 120 EPP; Lighting—Strobe)

Lighting Ratios. The lighting ratio in a portrait is the difference in exposure between the highlight areas (controlled by the main light) and the shadow areas (controlled by the fill light) on the subject's face. The lighting ratio in a portrait is expressed numerically as a ratio, like "2:1." This indicates the difference in stops between the highlight and shadow—in the case of a 2:1 ratio, the difference is one stop.

Whether you are working with natural light or artificial light, controlling the lighting ratio will create the mood of the portrait. Low light ratios are those where the difference between the highlight and the shadow is small; high ratios are those where the difference between the

highlight and the shadow is large. A 2:1 ratio has very light shadows that show only minimal roundness on the face. It is often used for children's portraits, fashion images, and in high-key photographs. A 3:1 ratio, a favorite for both color and black & white portraiture, shows more roundness and is flattering for average faces. Higher light ratios (4:1, 5:1, and higher) are often used when a slimming effect is desired on the face and in low-key images. In the higher ratios, shadow detail may be almost eliminated to create a very dramatic look. Black & white film, because of its higher latitude, is often favored for images with high lighting ratios.

The lighting ratio for a portrait is measured using an incident-light

meter or flash meter. As noted above, it is the difference between the highlight and the shadow that determines the lighting ratio. If the measurement of the highlight is f16 at $^1/_{60}$ second and the shadow is f11 at $^1/_{60}$ second, the lighting ratio will be 2:1 (the highlight is one stop brighter than the shadow). If the measurement of the highlight is f16 at $^1/_{60}$ second and the shadow is f8 at $^1/_{60}$ second the lighting ratio will be 3:1. Most conventional portraits are either 2:1 or 3:1. Again, if you want to create a more dramatic effect, consider using a higher ratio.

Contrast Ratios. It is also important to take contrast ratios into account when you are setting up your portrait. The contrast ratio is

determined by using a reflective meter and measures the reflected light off different colors/tones within the shot. For example, if you are shooting a portrait of a dark-skinned subject wearing a bright white shirt, the shirt will give you a much higher reading with your reflective meter than the face. This will guide you in balancing your lighting to compensate for the differences in reflective qualities within the frame.

Film Latitude. The latitude of a film is the number of stops from the lightest highlight with detail to the darkest shadow with detail. This is an important factor in determining your lighting and contrast ratios; for best results, these must not exceed the limits of the film you are using. If you use a high lighting or contrast ration with a film that has a narrow latitude, such as color slide film, you will lose more detail in the shadows than you would with a film with a wide latitude, like black & white negative film. When you are shooting portraits with color slide film and you want to maintain some shadow detail, it is therefore advisable to restrict the ratio to 3:1.

Keep in mind that your eyes can see a much wider array of contrast than any film. Therefore, what *you* see in you portrait setup is not what you get *on film*. Until you have mastered how to previsualize the lighting of a scene and how it will appear on your film, it is imperative that you use your meter carefully and with your film in mind. By determining the relationship between the lighting ratio and the contrast ratio, your meter will guide you in controlling your lighting to create the effect you want.

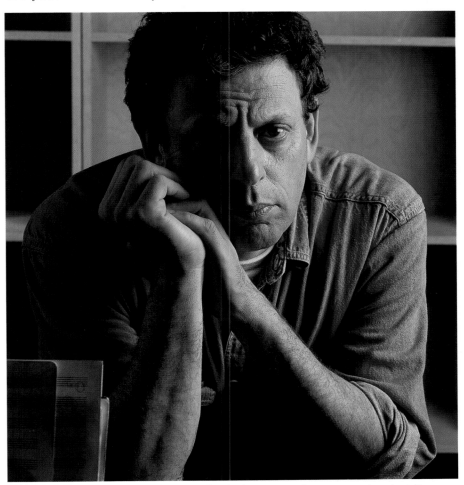

I photographed Phillip Glass, the great classical composer, for a personal project. Because I am familiar with his musical style, I kept the lighting and background minimal. I used split lighting, and cleaned out the bookshelves in the background to get rid of visual distractions (be sure to get your subject's permission before moving any of their belongings). (Camera—Hasselblad; Lens—120mm; Film—Fujichrome RDP; Lighting—Strobe)

8. COMPOSING THE PORTRAIT

*T*HERE ARE MANY WAYS TO COMPOSE A PORTRAIT. THE CHOICES you make will depend on the environment, the subject, knowledge of visual design, and instinct. This chapter will discuss some of the basic rules of visual design that will help strengthen the content of your portrait.

▼ RULE OF THIRDS

Rule of thirds is an aid for creating stronger compositions. According to this guideline, when composing your portrait you should mentally divide the frame into nine equal sections separated by lines. Placing the important element in your portrait on or near an intersection of these lines creates an image that appeals to our sense of beauty, emphasizes the subject, and is more dynamic. The lower right intersection is considered to be an especially pleasing place to compose a subject within the frame.

▼ FOREGROUND AND BACKGROUND ELEMENTS

In portraiture, the face is the primary subject. The scene or items with which you choose to surround the primary subject should support it, not distract from it. Each layer—foreground, middle ground, and background—serves the portrait in different ways. A visual element placed in the foreground becomes a framing device that encloses

Tips The risk of using a foreground element as a framing device is that it may distract from your subject—especially if the foreground is brighter than the subject or out of focus. Objects in the foreground that are out of focus can become distractions because your mind will try to define them.

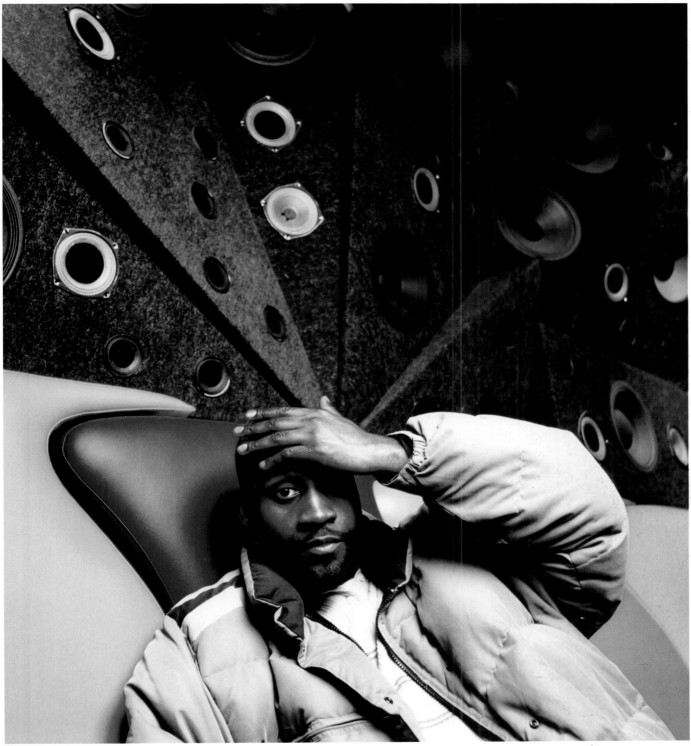

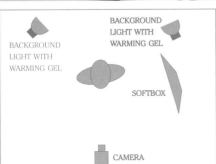

I was asked to photograph Pos, a member of the group De La Soul, for British Television's Channel 4. I had seen a wall of speakers in the lobby of his old record label, Tommy Boy, and felt it was an appropriate backdrop for this portrait. I shot this image on medium format film using a 120mm lens. A large light box was placed to the left of the subject, and two kicker lights were fitted with a warming gel and positioned on each side.

Breaking a frame into horizontal and vertical thirds will help guide the placement of your subject. To create stronger compositions place your subject on or near an area where the lines intersect. This portrait was lit with one direct head with a 40° grid and diffused with spun glass. A hair light was added to separate the subject from the black background.

I was asked by *Business Week* to photograph William Pedersen, an architect with the firm Kohn, Pedersen, Fox Associates PC. The image I created uses foreground elements and repetitive designs to draw the viewer into William's studio. For this shot, I used my Hasselblad with a 120mm lens (telephoto). I placed a softbox to the left of the subject and used an additional strobe in the room behind the subject to create depth.

your subject. This can include any number of things—a doorway, window, branch from a tree, your subject's arms and hands, etc. Background elements can also contribute to the strength of the portrait by adding depth or providing context. Using repetitive shapes in the background can strengthen the graphic quality of the portrait by reinforcing the form of your subject.

Here you can see how the background of an image can reveal the context and serve to create a narrative. This image was shot on a medium format Hasselblad camera using a 50mm lens (wide-angle). A softbox was placed to the left side of the frame and was set to balance with the light on the house in the background.

Above—I shot this editorial portrait of Arthur Ochs Sulzberger, Chairman Emeritus of the *New York Times*, at the Metropolitan Museum of Art. The repetitive columns and oval window in the background strengthen the composition of this portrait. (Camera—Hasselblad; Lens—50mm; Film—Fuji Provia; Lighting—Strobe combined with ambient tungsten) **Right**—It's very easy to get distracted when you are photographing people. As a result, photographers may forget to look at what is around their subject.

▶ CONTROLLING PROXIMITY

Proximity is defined simply as the distance between objects. In photography, the apparent proximity can be manipulated by lens choice. In chapter 4, I explained that the telephoto lens compresses planes, making background objects appear closer to middle and foreground objects. If there are strong shapes behind your subject, such as tree branches, signs, etc., there is a good chance that, by compressing the planes, your tele-

photo lens will cause those shapes to appear as if they are growing out of your subject's head. You can avoid this by opening up your aperture to throw the background out of focus, changing your point of view, or choosing a different lens.

▶ VISUAL BALANCE

Good visual balance in a portrait draws the viewer's attention to your subject; poor visual balance distracts the viewer from the subject. Each element in your photograph carries visual weight. The visual weight of an object is affected by negative space, tonal value, and color.

Negative space. Negative space (an area that is void of visual elements or lacks focus) does not compete visually with the subject. When your subject is surrounded by negative space, the viewer's eye naturally goes to the subject. This creates a feeling that you may wish to use in certain situations.

Tonal Values. Brighter elements also attract more visual attention than darker ones. For this reason, you may want to subdue lighter-toned background and foreground elements that distract from the portrait.

I used negative space to isolate actor John Seda in this portrait.

Top left—The white laundry hanging in the background creates a distraction in this family portrait. **Top right**—By changing the camera perspective to "lose the laundry," the family becomes the center of attention.

You can achieve this effect by reducing the light on those elements, increasing the light value on your subject, moving small bright objects out of the frame, or simply changing your viewpoint.

Color. Colors also play a major role in directing your eye. Warm colors (red, yellow) tend to advance in the frame and seem vibrant, while cool colors (blue, green) tend to recede and seem more subdued. For this reason, given two colors of equal tonal value (brightness), our eyes are first drawn to the warmer one. The contrast of warm colors against cool colors also increases the visual dynamic of the frame. You may want to consider this when picking out backgrounds or wardrobe.

▼ IMPLIED SHAPES

It is not necessary to keep every detail in focus in order for the viewer to understand the context of the image. In the study of visual illusion, the mind's ability to complete a partial or suggested element is referred

This is a good example of how colors can create the mood of a portrait. I created this image during a session with Pos, member of De La Soul, for British Television Channel 4. (Camera—Hasselblad; Lens—50mm; Aperture—f8; Shutter Speed—$^1\!/_{15}$ second; Film—Fuji Provia; Lighting—Softbox to one side combined with bounce light on the background)

When this great jazz musician, the late Joe Henderson, came to my studio for promotional portraits, we spent an afternoon shooting various outfits changes and poses. During this shot, he was telling me about the time when his saxophone was stolen in New York and found in San Francisco five years later. He turned away from the camera, and I took this photo. The partial saxophone in the frame is enough to identify but not so much that it distracts from the subject. (Camera—Hasselblad; Lens—120mm; Film—Fuji Provia; Lighting—One strobe with a light box)

Above left and right—Both of these images use the triangle to strengthen the composition. My portrait of artist William T. Williams (above left) is framed by a triangular highlight in the background (Camera—Hasselblad; Lens—120mm; Aperture—f8; Shutter Speed—$^1/_{30}$ second; Film—Fuji Provia; Lighting—Softbox on the subject for fill). I positioned the Shewmon family (above right) to create a human triangle (Camera—Hasselblad; Lens—120mm; Aperture—f8; Shutter Speed—$^1/_{125}$ second; Film—Kodak Plus X; Lighting—Flash fill). **Facing page**—To create this Avedon-style photograph, I asked archaeologist Kyriakoula Micha to pose for me. I found her to be a visually intriguing subject and thought the detail I could achieve using black & white film in the medium and large formats would help to bring out her strong personality. (Camera—Sinar 2; Lens—210mm; Film—TMax 400; Lighting—Strobe)(94, 95)

to as visual completion. Your mind also completes a visual image using your memory. You know that most people have arms, legs, two eyes, etc.—even if they aren't shown in an image. This is extremely important to remember when you are framing your portrait, since every visual element in the frame can enhance or distract from your subject.

can become distractions. Photographing his subjects on a white background and shooting with a large format camera, Richard Avedon is a master at creating graphically clean and highly detailed portraits. His style of portraiture strips away any possibility of distraction and draws you immediately to the unique personalities of his subjects.

is the triangle. King Khufu realized this in 2589 BCE when he began building the Great Pyramids at Giza. Positioning your subject(s) or visual elements in various geometrical shapes will strengthen your composition and create visual flow.

▼ DISTRACTIONS

Charles Mingus once said, "Anyone can make the simple complicated. Creativity is making the complicated simple." The adage "less is more" holds very true when composing a portrait. Too many graphic elements

▼ GEOMETRY

If you could wear special glasses that transformed everything you see into geometric forms it would become clear that some forms are more balanced than others. One of the most balanced geometric forms

9. GETTING READY FOR THE SHOOT

*a*S A PORTRAIT PHOTOGRAPHER, IT IS EASY to become distracted by extraneous details. Unlike a still-life photographer, who has time to contemplate composition, lighting, and overall concept, the portrait photographer has to make quick, analytical, and ulti-

This image is composed in a very traditional manner. The couple is framed in the center. A Hensel 1200 porto-pack was used as a fill flash. A gobo was placed to the left to keep the sun off their faces. (Camera—Hasselblad; Lens—120mm; Film—Fuji 160 NPS)

Left—The second image in this series is less serious in composition, emphasizing the editorial comment. I raised the fill light on the left to bring out the sweat running down the groom's forehead. A gobo was used to block all the light from the sun on the subject's faces. (Camera—Hasselblad; Lens—50 mm; Film—Kodak 120 Plus-X) **Right**—A wide-angle lens was used in this image to create distortion at the corners of the frame. The lighting was the same as in the first photo. The intent was to capture an offbeat, candid moment to sell the product. (Camera—Hasselblad; Lens—50mm; Film—Kodak 120 EPP)

mately intuitive decisions in the moment. To minimize the distractions and maintain your focus, it is important to work out all the controllable variables before the session begins. If you like, you may want to run practice sessions with forgiving subjects (like yourself or your friends and family) before moving on to other clients.

▶ OBJECTIVE OF THE SHOOT

In a photographer's *ideal* world, the only client is the photographer. In the *real* world of making a living, while it is important to keep sight of your personal vision, it is also critical to express your vision in harmony with the client's expectations. This does not mean abandoning your approach (hopefully you have been

hired expressly because of your individual approach), but rather working with the client to meet their objective(s) while maintaining your artistic integrity.

The images above and on the facing page utilize the same elements to meet different objectives. The first is a straightforward wedding shot to put in a silver frame on the mantel. The second was taken in an editorial style that could illustrate an article titled "Will it Last? Marriage in the 21st Century." The third was taken with a commercial angle, as if to advertise a brand of soda.

▶ PRACTICE PORTRAITS

Subjects. The only way for you to improve your portrait skills is by taking portraits. The best subjects are

the ones you know best, the most accessible being you. Although most photographers abhor having their portrait taken, experiencing the self-awareness that can arise through creating a self-portrait can lead to a better understanding of what your subject is feeling during a session. Family and friends also make great subjects for practice—in fact, they may be the source of your best portraits. With a trusting relationship already established, you might feel freer to take risks and be creative. Of course, even with close friends, it is important to respect their time and space.

Planning. Plan the type of portraits you want to take before you start shooting. For instance, if you need to improve your skills with fill-

I shot this photo of comedian/author David Brenner to promote his book in a travel magazine. The sky backdrop was rented, and wardrobe stylist was hired. David provided the comic relief. The main light was a large softbox. A hair light with an 81A warming gel was placed on a boom stand above the subject and powered one stop brighter than the main light. Two strobe lights were used to illuminate the background. The image was shot in the medium format using a 120mm lens and an exposure of f11 at $^1/_{125}$ second.

flash, scout the location first, checking the weather conditions and the direction of the light. Preplanning allows you to concentrate on the process of creating the portrait.

Consider Black & White. You might find it useful to practice with high-speed black & white film. This will allow you to shoot both indoors and outdoors and, by discarding color, it will help you concentrate on composition and visual balance. If you have access to a black & white darkroom, you will be able to make your own prints.

▶ STUDIO PORTRAITS

The studio environment enables the portrait photographer to take control of all the elements. Free from the burden of coping with the weather, the time of day, or transporting equipment, the portrait photographer has the opportunity to test lighting, film, and ideas in a controlled environment.

The Personal Touch. Think of your studio as your home, and your subject as an old friend dropping by for a visit. Create a relaxed environment that will make your client feel welcomed. Have refreshments on hand and a variety of options for music. Show them the dressing room so they know they have a private space to prepare themselves for the photo shoot. The only concern they should have is where to stand (or sit, or jump, etc.).

The portrait's intent and your subject's personality will dictate the ambiance. Don't assume what your subject's likes and dislikes are; ask them. For example, if you are photographing a hip-hop artist it doesn't mean they like to listen to hip-hop music—they might prefer opera.

Most importantly, you need to engage your subject in the experience. It is your responsibility to take control of the situation and become the director. Your subject is depending on you to make them look good, and it is your confidence that will strengthen their belief that everything is going well.

Technical Concerns. As much as possible, all technical concerns should be taken care of prior to the subject's arrival. For example, your lighting should be generally set (you can make changes once you know how your subject looks under specific lighting). During the session, having these details taken care of will allow you to relax, give clear directions, and concentrate on bringing out the best in your subject. If there should be a technical meltdown— which *does* happen—it should appear to be "no big deal." After all, you are a professional and you have a back-up plan.

Creativity. The bottom line is to keep it fun and keep the creative

In the studio, you'll have a lot of choices to make, but it will all be under your control.

Left—Going on location can sometimes mean packing everything but the kitchen sink. It helps to have a strong assistant, like Dante, to help transport the baggage and track the cases to be sure they get where you are going. On the left is the stand case, containing light stands, tripods, umbrellas, and light boxes. The five cases on the right contain cameras, strobes, reflectors, extension cords, fuses, A-clamps, gaffer's tape, and a toothbrush. When you travel this heavy, it's worth spending the extra money on carts. **Right**—Staying organized on location is always a challenge. One way to be sure you haven't left any equipment behind is to organize your cases. If you have forgotten an item, you will see an open spot in your case. I organize my location camera case with the 35mm lenses and cameras from upper left and working clockwise. The medium format cameras begin with my 120mm lens and end with my Hasselblad body. Extra batteries are hidden under some of the lenses, and I also pack a magnifying lens.

juices flowing. Keep an open mind to change—listen to your subject and you may get some great insights and ideas. A successful portrait shoot should be carefully planned and organically executed!

▼ LOCATION PORTRAITS

Organization. Location portrait photography demands detailed preparation, great organizational skills, and a good back up plan. When you go on location you literally take your studio with you. If possible, take two or more of each item of equipment (especially an extra camera!), plenty of extra batteries, and more film than you think you need. Having a checklist of all the equipment you need to bring is a great way to keep on track. An alternative method is to pack your equipment so that each item has its own compartment. That way, when you check your cases before you go on location, you will know if something is missing.

Distractions. There are many more distractions to contend with on location. If possible, hire a professional assistant. As a last resort, talk a friend into going with you. You will at least need someone to help carry your equipment and keep an eye on your stuff while you are shooting. As in the studio, the more variables you eliminate, the better chance you have for a successful location portrait. This means scouting the right location, setting lights, and preparing your equipment before the shoot so you can focus on your subject during the session.

Above and facing page—My assistant Ryan (above) loads film backs for my portrait session with Jeffery Lurie, CEO of the Philadelphia Eagles (facing page). (Camera—Hasselblad; Lens—150mm; Film—Kodak EPP; Lighting—Strobe light mixed with daylight)

10. CREATING VISUAL MAGIC

*I*N MY EXPERIENCE, A LOT OF PEOPLE RATE HAVING their portrait taken right up there with going to the dentist. However, you cannot be distracted by your subject's insecurities. The key is to stay firm with your objectives and to come away with a good portrait. The following are some of the key elements to keep in mind.

This conceptual portrait of Rene was taken for the New Paradise Laboratories' original production of Stupor. (Camera—Hasselblad; Lens—120mm; Film—Kodak EPP)

When talking with Murray Horwitz before the portrait session, he told me that he used to be a clown with the Barnum and Bailey Circus. What better way to photograph him and his son Alexander? (Camera—Hasselblad; Lens—150mm; Film—Kodak EPP)

▼ LIMIT DISTRACTIONS

In order to achieve the best results, you must control the session and limit distractions. This includes other people in the shooting area who, perhaps with the best intentions, are trying to put your subject at ease. While this might sound like a good idea, what actually tends to happen is that your subject becomes distracted and you end up with a lot of frames of the subject looking away.

▼ WHAT TO SAY?

Build a Rapport. It is difficult to get a friend to relax in front of the camera, let alone a stranger—and the majority of your subjects will be strangers. You may have only ten minutes to photograph, or you may be fortunate enough to have the whole day. Whatever the situation, it is important to create a positive rapport with your subject. Imagine that this person is an old friend and ask them questions about what is going on in their lives.

Every photographer has their own way of working with people. I have read that Francisco Scuvullo likes to initiate small talk by asking questions like "What did you have for breakfast?" According to Scuvullo, this helps to keep the subject's mind off being photographed. Irving Penn is known to physically manipulate his subject's body to bring out the strong graphic quality of the form.

Some photographers prefer to say little and let their subjects devise their own looks. It is easier to describe what *not* to say than what to say:

1. It is fine to shower the subject with compliments, but they should be realistic and sound sincere.
2. Unless you have a true comic gift, don't do a stand-up routine to get your subject to smile.
3. Avoid hot topics like politics and religion—or save them for after the session.
4. Try to prompt short responses. If your subject is speaking all the time you will have lot of frames with their mouth open.
5. Keep the talk friendly, but not too personal.
6. Avoid talking about yourself; remember this is about them not you.

Do Your Homework. Learn about your subject before the session. If it is realistic, try to set up a meeting ahead of time so you can get to know each other. If it's not possible to meet, which is usually the case with editorial and commercial work, ask their secretary or publicist for some information about the person—or look them up on the Internet. Find out about their outside interests, what their family is like (remember, not too personal), where they were born, etc. Any information you can gather will contribute to the flow of a successful portrait session.

I shot these four images with the help of a professional makeup artist. Extreme makeup treatment is the exception rather than the rule in portrait photography. The objective of these portraits, however, was to create mood using color. Various warming gels over the main light altered the model's skin tone. (Camera—Hasselblad; Lens—150mm; Film—Fuji Provia; Lighting—Strobe)

Demonstrating care for your subject will create trust and allow them to drop their guard and relax.

► MAKEUP AND HAIR

Professional Makeup and Hair.
No face is photographically perfect. Oily skin, blemishes, and dark circles under the eyes can all undermine the effort you put into setting up your portrait. Professional makeup and hair artists can make a world of difference in the final outcome of your portrait. They can get rid of flat or frizzy hair, accent important features, hide blemishes, remove dark circles under the eyes, and create fuller lips.

Talk with the makeup artist about the style of portrait you are creating. A good make-up artist will collaborate and with you and ask whether the makeup should have a light or heavy touch and whether the final

use of the image will be black & white or color. Makeup and hair artists are essential in fashion and commercial portraiture, and are sometimes used in editorial work—especially when photographing a well-known personality.

Do-It-Yourself Makeup and Hair. There are simple makeup applications you can use when you are not working with a professional makeup artist.

The most basic and effective makeup is translucent powder. The powder is applied with a brush over shiny areas of the face, such as the nose and forehead, where natural skin oils are more abundant. This reduces the highly reflective areas that are distracting in the final print. Be sure to wrap a towel around your subject's shoulders to prevent the powder from dropping on their clothes.

Another simple-to-use makeup trick is to employ concealer to disguise blemishes. This should be applied with either a small sponge or a fine brush and comes in different shades to match each subject's skin tones.

If you do not feel comfortable applying makeup and do not have the budget for a makeup artist, ask the subject if they know someone that can help. There is a good chance they know someone at their salon that can apply make-up and fix their hair. They may also feel comfortable applying their own makeup, especially if they work in entertainment.

� WARDROBE

The wardrobe your subject chooses can reveal just as much about them as their faces. It is important that your subject feels comfortable with what they wear, but it is just as important that it looks good. There is nothing more disappointing than looking

Left—I like to travel with a portable makeup kit that is compact enough to put in an equipment case. Essential items to include are: translucent powder, applicator brushes, hairbrush, hair spray, combs, paper towels, cotton swabs, sponges, concealer, a mirror, and clothespins for adjusting the fit of items in the wardrobe. **Bottom Left**—The right half of the face shows how glamour makeup appears in black & white; the left side has no make-up. **Bottom Right**—The same glamour makeup as it appears on color film.

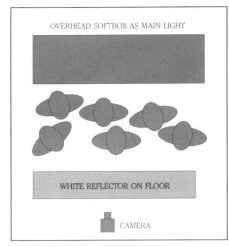

I shot this image in my studio. The girls were auditioning for the television show *Star Search* and needed a promotional shot in their uniforms. To isolate them and bring out the vibrant color of their outfits, I put them against a black background and placed a large softbox on a boom stand about 3' above their heads and angled at about 45°. (Camera—Hasselblad; Lens—120mm; Film—Fuji Provia)

at the proofs and finding wrinkles, clashing colors, or distracting patterns in the clothes—all of which can distract from the face.

Professional Stylists. Some commercial and editorial portrait shoots will budget for a professional stylist and/or a wardrobe person. The role of the wardrobe stylist is to find just the right clothing for the individual subject.

Their decisions are based on current fashion trends, the editorial content (the art director or photo editor may want to convey a specific point of view), or simply personal taste. When creating a stylistic portrait, a good wardrobe professional will reduce your stress. The responsibilities of the wardrobe stylist include:

1. Communicating with the photographer and client to get a sense of their needs.
2. Shopping for the right clothing and managing the wardrobe before and after the shoot.
3. Making sure the clothes are wrinkle- and lint-free during the shoot.

Do-It-Yourself Wardrobe Styling. For most portrait shoots, you will not have the budget to hire a professional wardrobe stylist—but the same rules listed above still apply. The responsibility of the wardrobe will fall upon your shoulders for these shoots. This does not necessarily mean you will have to go shopping and choose the clothing, but you will need to advise your subject on what to wear. The following are some guidelines:

1. Ask your subject to bring several choices of clothing and to stay away from busy patterns.
2. If you do not have a clothes steamer, ask your subject to be sure the clothes are clean and wrinkle free.

3. For color images, ask the subject what colors work well with their complexion. If they aren't sure, ask them to bring several colors. Black and gray are safe choices for anyone.

On the day of the session, you will need to help select the best outfit(s) and make sure they will look their best in the portraits. This includes eliminating wrinkles and lint, fine-tuning the fit, and making sure the garments lay naturally on the subject in the final pose. The following are some guidelines:

1. While you are shooting, be aware of wrinkles, folds, and lint on the clothing and take the time to remove them. Lint can be quickly removed with gaffer's tape.
2. To give shirts, jackets, or dresses a more fitted appearance, use A-clamps or clothespins to gather and pinch the fabric behind the subject's back.
3. If your subject is wearing a jacket and will be seated, have them sit on the tails of the jacket to pull down the lapels.

▶ POSING YOUR SUBJECT

There is no one right way to pose your subject. You should approach every portrait with an open eye. Don't get stuck with what worked before, and don't be afraid to try different positioning in order to find the right one for the session. If you follow this advice, the process will always be fresh and the person you are photographing will receive the attention they deserve.

When you are considering how to position your subject you should first take into account their shape. Is their face round or angular? Do they have high cheekbones or hollowed cheeks? Is their neck long and thin or short and thick? Is there a unique birthmark or a distracting scar? Are

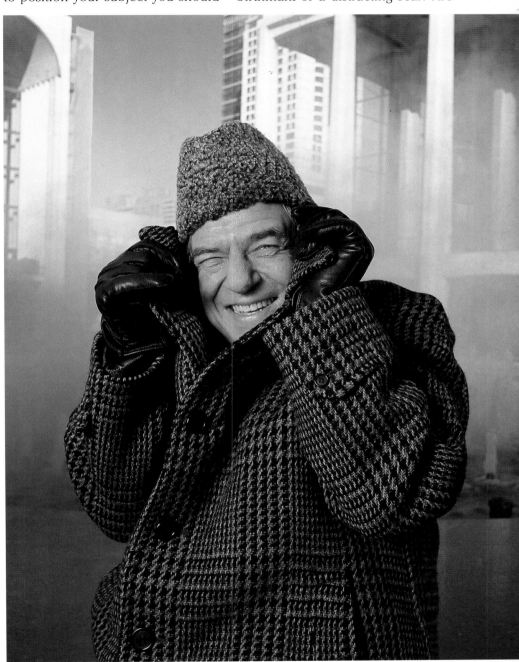

Sometimes, letting the environment dictate the way you pose your subject will result in a more interesting portrait. When I was asked to photograph George Weissman, Chairman Emeritus of Lincoln Center in New York City, it was a cold, January morning. It made visual sense for me to take advantage of the steam coming off the fountain for the background. The bonus is that Mr. Weissman came out with a great hat! (Camera—Hasselblad; Lens—120mm; Film—Fujichrome RTP; Lighting—Flash fill and ambient lighting)

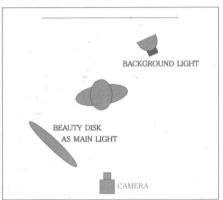

BACKGROUND LIGHT

BEAUTY DISK
AS MAIN LIGHT

CAMERA

When I posed actress Lourdes Benedicto with her shoulder square to the camera and her chin raised (left), it gave the impression that she was confident but also somewhat distant. For the second portrait (right), I had her drop her shoulders, move her left shoulder back, and lower her chin while keeping her face forward. This created a warmer, more inviting appearance. The portrait was lit with a 22" reflector (beauty disk). A Fresnel projector light was placed on the background with a window template. (Camera—Hasselblad; Lens—120mm; Film—Kodak Plus X)

their eyes deep set, or is there one eye that is sleepy? As you direct your subject while looking through the viewfinder, you will be able to see the changes as they occur. Based on these observations you can refine poses that are flattering and fit the intent of the photograph.

▶ GIVING DIRECTION

Once you've set the scene and positioned your subject, it is time to direct. Since no one's face is perfectly symmetrical, your subject will photograph better on one side—yes, it is true; we all have our "good side." Ask the subject to turn $^3/_4$ to the right and then to the left as you look through the viewfinder. Closely observe how the shape of the face changes. Does the nose get bigger or smaller? Do their eyes appear more opened or closed? What happens when you ask them to lower their chin? Do the cheekbones appear more round? Does a double chin appear? This is where your aesthetic sense and intuition play a major role. The key is to keep your subject moving while you stay alert to subtle changes and find the best possible position for the shot.

*I*T IS IMPORTANT TO START PLANNING WHAT TYPE OF portrait photography you want to pursue. This does not exclude you from entering other markets but it will force you to take action in starting your business. It is great to have the ambition to shoot all the cover portraits for *Rolling Stone*, but it's not very realistic—at least when you first start out. While

This composite photograph was shot for a brochure for Pratt University in New York City. The image of the students was photographed with a 4"x5" camera in front of one of the building on campus (Camera—Toya 4"x5"; Lens—150mm; Film—Fuji RDP II; Lighting—Flash fill). Then, the transparency was placed inside the ground glass, lit from behind, and photographed (Camera—Toya 4"x5"; Lens—210mm; Film—Fuji RDP II; Lighting—Strobe).

you are building your portfolio to send off to *Rolling Stone,* you might want to gain experience in other portrait venues and pay the bills. There are many specialties to consider and they often overlap. The following is a sample of opportunities that await you. Whatever your specialty, persistence, perseverance, and patience will play a major role in finding work.

▼ SCHOOL PORTRAITURE

Schools always need portraits of their students and graduating classes for personal use and school publications. If you are an organized person who works well with children and young adults, this can become a source of steady income and a great learning experience.

How to Find Work? The easiest way to get started is to call the principals of the schools in your area and ask who shoots their portraits. Most schools contract the work out to large studios that then hire full- and part-time staff to shoot the needed portraits. If this is the case, find out who they are and talk with them about opportunities. Some companies provide all the equipment and the only thing you need is a car and the desire to take portraits.

▼ FAMILY PORTRAITS

There is always a need for high-quality family portraits. The skills required are: a strong sense of composition, strong directorial ability, and an easy-going disposition. Families

Celebrating a milestone birthday, Rachel Allen Fagerburg hired me to photograph her and her daughters. Four of her daughters perform on string instruments with various orchestras around the country, so these were used as props. (Camera—Hasselblad; Lens—120mm; Film—Fuji Provia; Lighting—Strobe with softbox matched for daylight)

can be a challenge to work with—especially if there is tension between the siblings or the parents. It is vital to diffuse the tension early. Keep the session lively and the individuals moving until you feel you have a strong composition. Photographing a group will require more attention from you to be certain that everyone is looking at the camera at the same time. It is always better to shoot more film and be sure you have it covered than to get the family together again and reshoot.

How to Find Work? Like school portraits, there are companies that hire photographers to take family

portraits. If you are starting out, this could be a good opportunity to learn the trade. If you intend to go it alone, you should have an appropriate portfolio ready to show potential clients. A family portrait photographer's portfolio should contain color portraits of children, babies, couples, and large groups. Location portraits of families at their home and on vacations make for an impressive presentation. Start by taking portraits of your own family and friends.

▼ WEDDINGS

Wedding photography is a great learning experience for a portrait

photographer. It teaches you many valuable lessons including: working with people under stressful conditions, on-location technical and visual problem solving, and working under pressure. After all, you only have one chance to capture the moment.

Fortunately, these moments come almost every weekend, year round. This means that, once you are established, you may find yourself in the position of never being without work.

How to Find Work? The best way to start out is to apprentice with an established wedding photographer. This way you will not only learn the technical aspects but also important lessons about the day-to-day process of running a business.

▶ HEADSHOTS

If you live in or near a big city there is a good chance that there are performers who need headshots. These are the portraits the actors submit to agents and casting directors and leave behind after an audition. The portraits need to show the performers at their best.

Top—Photographing weddings can be fun and lucrative. I was asked to travel to Cape Cod to photograph Sarah and Brian Nixon's wedding—not a bad way to spend a summer weekend! (Camera—Hasselblad; Lens—80mm; Film—Kodak Plus-X; Lighting—Fill-in flash) **Bottom**—It is important that you and the actor talk about the style of headshot they are looking for before the portrait session. Actress Marky McCool needed a headshot with a commercial look.

To create a successful headshot you must have a good idea of how to light a commercial portrait. A good headshot should appear natural and the lighting should be kept simple. Under most circumstances one light (a softbox) and a reflector will be sufficient. If you are using a dark background, a hair light and background light will also be necessary to separate the subject from the background. The key is to avoid lighting that distracts from the face and eyes. The eyes should be lit either with a kicker light from the camera position, or a reflector from underneath the subject's face.

How to Find Work? To find business, it is a good idea to post your flyers or promotional materials at local talent agencies, theaters, and acting schools. If you have a bigger budget, run an ad in the local actors' trade publication.

▼ PUBLIC RELATIONS
AND CORPORATE COMMUNICATIONS

The objective of these portraits is to represent the company. Therefore, it is important to show portraits of people dressed in the appropriate attire and looking their best. The venues for these portraits include press releases, brochures, and annual reports.

How to Find Work? Call the companies directly and ask if they use freelance photographers. Find out if they use an in-house designer or if they contract their photography to an outside agency. If they use an

Above—Anthony McCall Design hired me to take portraits of the partners and associates from the law firm Covington and Burling for their brochure. (Camera—Fuji GX-680 II; Lens—100mm; Film—Kodak Tri-X) **Facing page**—Although this image was ultimately used in an annual report, the client wanted an editorial look. The office was very plain with an old map of the world. The use of colored gels and red books provided a more interesting environment for Richard Orne, the former executive director of the non-profit organization The Committee to Protect Journalists.

outside firm, call them and ask if you can set up an appointment to show your work to their design team.

▼ EDITORIAL/MAGAZINE PORTRAITS

There are many consumer and trade magazines that hire portrait photographers to photograph people from all walks of life. Editorial portrait photographers are hired primarily for their personal style and, as a result, they often have the most creative freedom when shooting a portrait for a magazine.

This is a very competitive market and it may sometimes feel like it

takes a Herculean effort not only to get work but to maintain it. This is compounded by the fact that many magazines are still paying editorial photographers the same fees they paid in the '80s. At times, it may make you wonder if you really want to pursue this path. As noted, however, it can be your most creative venue and the visibility of your work in a high-profile magazine may compensate for the disadvantages.

How to Find Work? There are literally thousands of magazines on the market covering a wide range of topics. Only a small fraction of the existing magazines are found on the newsstands, but there are Internet agencies that have complete lists of all the magazines, along with their photo editors and creative directors, available for a fee. Adbase, Steve Langerman Lists, and Creative Access are three good examples of agencies that can help expedite the process of data collection. An alternative is to search the Internet or buy the magazine and write down the names of the photo editor and visual editor.

However you go about it, once your list is compiled, it is time to create a marketing plan. This involves an initial phone call to the person who hires photographers. Try to set up a meeting or drop off your work for review. Once you have narrowed your list to a reasonable number, it is time to create a promotional mailing. Your promo should be sent out at least four times a year, and paired

with follow-up phone calls. You should also have new work to show on a regular basis. The key to staying sane is to stay busy creating new images and not waiting for the phone to ring.

▶ ADVERTISING PORTRAITS

Portraits for advertising campaigns can range from fashion models to character actors to regular folks. They can be as simple as a headshot against a mottled backdrop, or as complex as a big production shot of a worker in a car factory. The art director or art buyer for the project will be looking for a photographer with a unique vision, a strong sense of style, the ability to work with people, and a command of the medium.

Powerful people.

Put our 50 million readers together—and the effect is extraordinary. In fact, if our readers weren't allowed to use Betty Crocker cake mixes, the brand would fall from the #1 spot—to #2. Building a brand? Don't forget the foundation.

Start with a family of 50 million. Start with The Digest.

Reader's Digest

An art director saw my book *Fathers and Sons* (Abbeville Press, 1989) in a book store and enlarged some of the images to pitch a concept to a potential client. His client loved the concept and the images. As a result of winning the account, I was hired to produce more portraits for the *Reader's Digest* advertising campaign for the next three years. (Camera—Hasselblad; Lens—120mm; Film—Kodak Plus-X; Lighting—Strobe light with softbox)

This is not a small order, but the financial rewards can be a great motivator.

How to Find Work? Once you compile your list of like-minded art buyers and art directors, it is time to create a marketing strategy. Set a time frame to send out promotions, make phone calls, and set up meetings to show your work. You may also want to look into advertising in photography source books, like *The Workbook* or *The Black Book*. If your work is unique, your presentation is clean, and you are lucky, you will get work.

▶ PERSONAL PORTRAIT PROJECTS

This is a special category that I feel is probably the most important in a photographer's portfolio. To maintain your high level of creativity, it is vital that you work on a personal photography project. This is a time when you no longer have to think about fulfilling another person's photographic needs and are free to shoot for yourself. It is a time for growth as a visual artist. Find a subject that is meaningful to you and start taking photographs in whatever manner your artistic intuition guides you. After a while, you will have a collection of portraits with your signature style. You may want to incorporate that style into your commercial work and see what happens.

What To Do with Your Personal Project? Once you have accumulated a body of work, shop it around to galleries. There is nothing

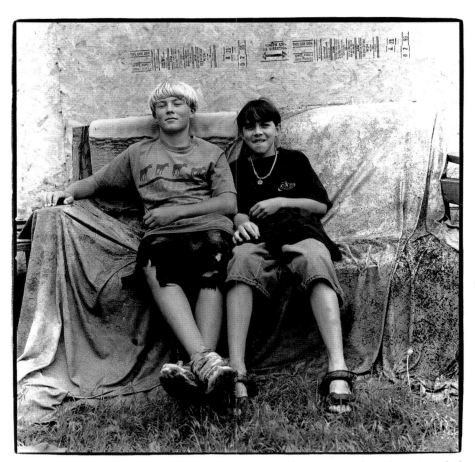

This is from my on-going project "Stickerville." For the past five summers I have attended and photographed a weekend gathering of talented musicians and their families. There is nothing more satisfying than taking pictures for yourself!

more satisfying and terrifying than a one-person show. Most galleries prefer that you send ten to twenty slides of your work along with a self-addressed stamped envelope to return your work. Do not expect an immediate response, but do follow up with a call if you have not heard from the curator within a month.

If you feel that your work fits a particular market, submit it to the appropriate book publisher(s). Most often, work should be thematic (fathers and sons, etc.). Research a publisher that has a history of printing similar books and call them to ask for their submission guidelines.

12. THE BUSINESS OF PORTRAIT PHOTOGRAPHY

*I*F YOU PLAN TO MAKE YOUR LIVING AS A PORTRAIT photographer, there are many skills you will need to develop in addition to those required to create memorable portraits. After all, it won't matter how wonderful your work is if no one ever sees it, or if you can't pay your bills. For creative people, like photographers, having to tend to the practicalities of running an efficient business may seem unappealing, but the importance of addressing these issues can't be overstated.

▼ BUSINESS PLAN

It feels great to get a call for a job and to get paid to take photographs but if, at the end of the month, your bills outweigh your invoices, it is time to reevaluate your business strategy. Like any business, the best way to establish a photo studio is with a realistic and objective business plan. Whether you become a school portrait photographer or a portrait photographer for the stars, you will need a plan that spells out your goals and what you're going to do in order to meet them.

▼ THE EXPENSE OF DOING BUSINESS

As you start fantasizing about what you are going to do with all the money a client just paid you, consider your fixed monthly overhead. When you receive your payment, deduct a third for federal/state/city taxes, a percentage for insurance (don't assume your homeowner's policy will be sufficient), and enough to cover overhead, maintenance, advertising, and retirement. What is left is your profit.

If you are just starting out, try to minimize your overhead (how much it costs to run your business). Begin with the basic necessities and see how your business progresses. Purchase photographic items as you need them, and allocate a percentage of your profits to pur-

chasing new equipment and supplies. Once you have established your business and are looking to maintain it, you still need to take your overhead into account.

The following is a hypothetical breakdown of the basic monthly expenses of doing business. Of course, overhead will range widely depending on the decisions you will make. However, the following will help you in determining the fees you need to charge to run your business.

Fixed Monthly Overhead

Office Maintenance

 Rent/mortgage$1000

 Telephone/fax/ISP150

 Electric100

Insurance

 Camera/liability100

 Health Insurance500

 Disability150

Advertising150

Office Supplies150

Retirement fund300

 Total $2500

The totals will change depending on where you live, whether you need family or single health insurance, the amount of camera equipment you are insuring, etc. You may also need to add other categories to this list for your business to grow. These could include: professional affiliation dues, equipment and technology updates, and office assistance. These could increase your monthly expenses significantly. Let's say this

adds $500 to your monthly expenses.

Unless you live in your studio, living expenses should also be included. You will need to budget for entertaining clients, sending a year-end thank-you gift, and updating your professional attire. If you are a location portrait photographer, your car becomes a key asset. You will need to budget for car maintenance and car insurance. Let's say this adds $1000 to your monthly expenses.

Using the above estimates, the expenses per month add up to $4000. Over the course of a year, this adds up to $57,600. If you work every day, you'll need to make $158 a day just to cover fixed expenses. However, a successful freelance photographer usually works more like ten to fifteen days per month (or about 180 days a year). When you divide $57,600 by 180 days, you find that you will need to make an average of $320 per working day to cover your overhead. If you were to charge less than $320/day for a shoot, you would actually be paying the client.

� PRICING

There is nothing more intimidating when you are first starting up your business than someone asking what you charge for your services. It is tempting to undervalue your services in order to build your client

base—but remember, once you set your price it may be more difficult to raise it later. The questions you need to ask yourself before you set a price are:

1. How are the photographs going to be used? Are they for personal use or for a national advertising campaign?

2. Are the photographs for one-time use, or does the client want unlimited use?

3. What is the competitive price for this particular job? Ask a veteran photographer in the area for advice.

4. Can you afford to take the job? Consider your time and expenses when providing an estimate for the job. If the job demands days of preparation and postproduction work, it may not be worth the fee.

5. Will the job further your career or strengthen your portfolio? If a high-profile publication asks you to shoot a cover shot of a celebrity but can only cover your expenses, take the job. If a client does not have a budget to photograph an employee for their internal newsletter but implied "there might be more work down the road," you may want to pass.

As noted above, the usage of the image needs to be considered when pricing. Pricing a portrait of a CEO for an annual report will be different than pricing a family portrait that will be displayed on the mantel. A CEO portrait for an annual report will have more commercial value than a family portrait. The key is to know the market value and set your prices accordingly.

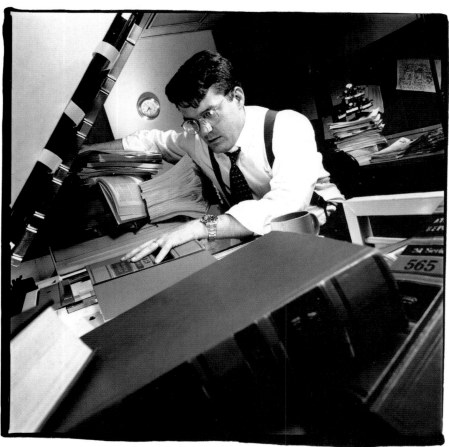

I was hired by Zeewy Design to photograph a recruitment brochure for the law firm Morris, Nichols, Arsht and Tunnell. The design concept was to dispel common myths through paradoxical photographs.

▶ COPYRIGHTS

Unless you sign a work-for-hire contract, the images you take are your property and you own the copyright. When you agree to a photo assignment, the client is licensing the rights to use your image for a specific amount of time and exposure. To avoid any misunderstanding with the client, it is important that you discuss the usage before taking on the job. Clarifying the usage will also help you in setting a fee for your work.

Maintaining the copyright to your images allows you to resell the images for additional income. It also prevents others from publishing your images without your consent. If a magazine or agency publishes your images without your permission you have, by law, the right to collect three times the value of the image used. If you have officially copyrighted your portraits with the federal government, you may also be awarded punitive damages.

▶ BUSINESS SKILLS

A complete discussion of the business of portrait photography falls outside of the scope of this book. However, there are many great resources for improving your skills. A good place to find help is through national organizations, such as PPA (Professional Photographers of America), WPPI (Wedding and Portrait Photographers International), or ASMP (American Society of Media Photographers). These organizations run frequent seminars for photographers on building their businesses. You might also consider taking business classes at a local college, or contacting a professional business planner or consultant.

13. PROMOTING YOUR WORK

𝒫**ROMOTING YOUR WORK IS ONE OF THOSE NECESSARY EVILS** in the business of photography. Competition in the photography field is very intense, and there is a lot of talent out there. It is important to create a marketing plan to get your work in the hands of prospective clients—and to make sure it stands out

This is my color infrared photography portfolio that is sent out twice a month to various art buyers around the country. I include promotional cards and business cards.

This photo of Kyle with a rattlesnake is one in a series of six promotional pieces that I sent featuring my recent work with color infrared film. (Camera—Canon EOS 1n; Lens—100mm; Film—Kodak EIR)

from the competition. The key is to be consistent with your plan and stick with it for at least a year before you evaluate the results.

�pThE PORTFOLIO

The first place to start is your portfolio. The work you put in your portfolio and its presentation will ultimately determine if you are chosen for the job. Your portfolio should contain your strongest work and represent your personal vision and style.

When you are ready to circulate your portfolio, it is time to research your potential clients. The market you are targeting will direct your research. For instance, if you wanted to target weddings, look in the yellow pages and find out who sells bridal gowns and caters wedding parties in your area. Approach them with your work and see if they have any leads. It may also be a good idea to run an ad in the yellow pages promoting your services. In contrast, if you wanted to target magazines you will need to get a list of photo editors and art directors. Once you have compiled your list, call them to ask if you could arrange a meeting to show your work or, alternately, send your portfolio.

▶ PROMOTIONAL MAILERS

If your potential clients are too far away to meet personally, it is time to create a promotional mailing campaign. Photo editors, art directors, art buyers, and designers are always on the lookout for new talent. Most do not have the time to go and look for these new artists, so it is up to you to show them what you can do.

When you have accumulated your dream list of clients, begin a campaign to send each person on the list at least one promotional card every two months. After the second or third mailing, give them a call and see if they would like to review your portfolio. The key is not to give up. There are many reasons you may not get an immediate response—and most of the time it has nothing to do with your talent. Finding work is a mixture of talent, timing, and luck.

There is a current trend to send visual e-mails to potential clients.

This is an inexpensive and quick way to show your work—but beware! Potential clients get barraged with junk mail every day, and if you abuse this simple method of promotion it may backfire. Be sure to place a notice on the bottom of your visual e-mail stating "If you would like to be removed from this list please hit reply and we will take you off the list."

▶ RESOURCE BOOKS

Photography resource books let you buy advertising space to promote your work. Resource books come out once a year and are sent out to specific markets that buy photography. Advertising in a commercial photography resource book, like *The Black Book* and *The Workbook,* costs between $3500 and $4500 per page (based on 2002 prices). Both books have a circulation of about 19,000 art buyers and art directors around the world. No resource book will guarantee work, but if your objective is to have your work seen by the "right people" (in the commercial field), and you have the budget, you should consider this venue.

▶ WEB SITE

In this digital age, it is essential to have your own web site. It is a great marketing tool and an inexpensive way to promote you and your work. Your web site should reflect the work in your portfolio. It is possible to have additional pages exhibiting other work, but keep it simple.

Potential clients who visit will want to navigate the site easily.

The images should be quality scans with a resolution of 72dpi. There is nothing more frustrating than waiting for an image to load because the resolution was set too high; monitors can only display 72ppi, so anything above that setting doesn't improve the image quality and increases load time. You should view your web site on both a Mac and a PC to be sure that it works well on both platforms, and you may want to try viewing it on several browsers (AOL, Netscape, Microsoft Explorer, etc.). If you have the budget, hire a professional web designer to construct your page. Once you are up and running, send out a promotional mailing announcing the launching of your site.

This promotional mailer was created to announce the launch of my web site. I found the model, Atlas, at my gym and bought an inflatable globe online.

14. WHAT THE PROS LOOK FOR

THE DEMANDS ON VISUAL EDITORS OR DIRECTORS OF PHOTOGRA-
phy are many. They are the gatekeepers of the visual editorial content of magazines. Their role is to find the right photographic talent to illustrate an article, or an image to compliment a fictional story. They look at hundreds of photographic portfolios a year, serve as members of the jury in photographic competitions, and attend photo openings in search of new talent to serve their publications.

Their busy schedules involve meeting with the editorial staff to discuss the upcoming issue, searching for photographers and images, scheduling photo shoots, and editing hundreds of frames of film—usually under a tight deadline.

When you are ready to show your work to a publication and, rather than scheduling a face-to-face meeting, they prefer to have photographers drop off their portfolio for review, don't get discouraged. This is a standard procedure and they, or an assistant, *will* look at your work. Do not expect an immediate response. If the publication is interested in your work, they will file your promotional piece (providing that you left one in your portfolio) for future reference. When you have new work to show, the key is to periodically check-in with the editor via promotional cards, visual e-mails, or an occasional phone call.

The following three interviews are from award-winning magazine photo/visual editors. I conducted the first interview personally in the office of Elisabeth Biondi, Visual Editor of *The New Yorker*. The second and third interviews, with Susan White, Photography Director at *Vanity Fair*, and George Pitts, Director of Photography at *Vibe*, were compiled from their written responses to a list of questions. Even if you don't plan to make commercial, advertising, or editorial photography your

specialty, read through the interviews. They give you a chance to learn what experienced viewers of photography consider the hallmarks of quality and style—and these apply to any genre.

Born and educated in Germany, Elisabeth's career in magazine picture editing began with the American launch of GEO *Magazine in the early 1980s. Subsequently, she moved to* Vanity Fair, *focusing on creating a style of lively, witty portraiture for the publication. After seven years at* Vanity Fair, *she moved back to Germany to become director of photography at* Stern, *a highly regarded weekly news and reportage magazine. Currently, Elisabeth Biondi is the visual editor of* The New Yorker, *a position she has held since 1996.*

Steven Begleiter: How did you become a photo editor?

Elisabeth Biondi: Art is what I have always been interested in. I came to America and had some not-so-important jobs, and it became clear to me that I wanted to work on a magazine and become a photo editor. My first job was working for the German magazine *GEO*, which opened an office in the United States. I had some experience in the photo world but not as a photo editor.

This turned out to be a good thing. It was a very small staff and we were working on the charter issue—the first issue in America. The executive director was Thomas Hoepker. He started out as a photographer, became an editor, then went on to work for *Stern* as an art director.

The point is that I had a really good photographer as a mentor. He taught me how to look at photography, how to not violate a picture, how to visually see the integrity of the story, and how to look visually at the story. The most important point is that I learned from a photographer not an art director, text editor, or any other person in the magazine structure.

My professional life has been the connection between magazine and photography. That is what I learned at *GEO*. Although I have evolved as photo editor, my experience at *GEO* and its photojournalistic style, shaped my thinking, the way I treat photography, and how I interact with photographers and magazines.

GEO was an extremely visual magazine. We would do fourteen pages of visual pieces; it was very beautiful, but not very successful. It was a contemporary *National Geographic*. *GEO* was successful in Germany, but when we launched it in America we made mistakes. For instance, the least favorite color in America is lime green and our cover was lime green with a die-cut cover image. Anyone who knows about the business knows you do not do a lime green cover with a die-cut—it just doesn't sell. Artistically it was very successful, but not financially, and eventually we were sold to Knapp Communications and they shaped it into a travel magazine.

Stern offered me a job, which I knew was safe, but I decided to go to *Vanity Fair*. *Vanity Fair* was a very different kind of magazine, and I wanted to experience another world of photo editing. It was shaky for me to work there since it was very different from *GEO*. I felt since I started my career late as a photo editor it would be important for me to see another world, to see the other side.

At *Vanity Fair* the editor was Tina Brown. Tina works in a very particular way. You worked with her vision; it was not the old style of photography, it had to be wittier and more original. She had Annie Leibovitz as the main photographer, setting the style and tone of the portraits.

After *Vanity Fair* I decided to go back to Germany and work for *Stern*. Then, I got an offer to work for *The New Yorker*.

What was the transition like to go from *Vanity Fair*, to *Stern*, to *The New Yorker*—which is not a visually driven magazine?

I think there are too many pictures in the world and too many bad pic-

tures. I feel it is more important to have pictures that do something, say something, that have content and are used sparingly. So to me it is much more my taste. I would like to use more pictures in the magazine, and I do push for more. We use about 50% illustrations and 50% photography for the magazine—but remember, the magazine is a literary magazine and is text driven.

It is a challenge, but I actually like it. Quite frankly, I would rather see a good illustration than a forced photograph. For some articles, a photograph is just not the right thing. Photography, in the end, is always tied to the object, and for some articles photography does not apply. If it is forced, it can become boring.

Do you have say over the size and layout of the images?
I work with an art director, and the larger the piece, the more time the staff and I spend with it.

What is the process you go through when you get the film back from the photographer?
We ask the photographer to edit the film and we see the A and the B edit. We basically see the B edit so that I can double check to see if it is a good edit. There are photographers that are good and bad editors. If there are some images we feel the photographer missed, we will add them. Then I edit the work—sometimes with the photographer, since I believe that it is a joint effort.

I believe it is good to have an outsider look at the work. Sometimes, the photographer is too close to the subject and may select an image because of the difficulty of the lighting setup or the situation—which is not the point; the reader wants an interesting, stimulating photograph.

Then the edit goes to another person who is less involved than I am but they sometimes see something that I do not. For instance, there may be three images that I like and can't decide between. Then I will ask this person what they think. The final say on which photograph we will use is the chief editor.

Are there any portrait photographers who have influenced you?
There are constant trends. Like waves that come and ebb and change again. As in any art, it never stays the same. Then you have classic photography. I think the last wave had to do with the Yale school of photography. They had a very cinematic way of looking at pictures and I think that had a strong influence.

Gregory Crewdson had a big influence; there is a symbiotic relationship with fashion photography and fine art photography. I think fine art photography had a lot of influence on the current portrait photography. I think it is changing again. I think it is becoming a little more human. I think the next trend of photography has to do with a more human approach. That may have to do with what happened on 9/11.

The images will become less artificial—and that is not a judgment, I just think it will become a little less rigid, a little looser and more human. I will be curious to see what the next fashion ads will look like and what the big September magazines will look like. The fashion people pick up the trends in photography, because they are always looking for something new, and that is why fashion is first to pick up on the latest trends.

The trends do influence me and our job is to incorporate the world in what we are doing. We have to see what is going on, and bring it to the magazine—that is what an editor does. I do get sick and tired of seeing the same thing too often. When every portfolio looks the same, then I know this style is on the way out.

I am a very editorial person; I read every piece, and I always talk to someone and find out what the piece is all about. I formulate in my head, as to what I think will be right, the best way to visualize the story. Then I pick the photographer who will express my thoughts.

I also direct but I do not dictate. The photographers need to be free to do what they do best—that is why we hire them. I don't go on the shoot because it is their shoot, not mine. I brief them before the shoot about the subject and what they should be doing conceptually. We go through three or four situations before the shoot, but when the photographers get there, sometimes things are total-

ly different. I never get calls from the photographer exclaiming, "Oh my gosh—what do I do?" They know enough to make decisions and come back with a good picture that works for us.

I believe the photo editor is the bridge between the magazine and the photographer. The decisions inside the magazine have logic, but someone from outside the magazine may have no idea of how we come to our decisions. We can be intimidating to photographers. I always hear photographers say, "I followed the assignment and I sent it in and no one called me back." It is my job to communicate what they are to do, what the intention of the piece is. Sometimes it is specific and sometimes it is general. What kind of photography we like is something else we have to communicate to the photographer as well.

What do you think of digital photography?

It is fine, as it doesn't matter as long as it works. We receive digital submissions, and printed images. The difficulty is when we get a digital image of a fine arts photograph for the fiction section, for example, and I am wondering what it really looks like, because I have not seen the original. My impression of the photograph is represented in a book, which is once removed from the original. I am not sure, for instance, what shade of red it was, since digitally it could have been altered.

In *The New Yorker* our photographs accompany an article, but do not illustrate it. The image enhances the piece and should intrigue the viewer to read the piece but it should not contradict any of the details in the fiction. For example, if the fictional character has black hair the image should have a figure with black hair. We will not show the face of the figure clearly because we do not want the reader to have a fixed image in their mind before they read the article. They should have their own fantasy of what the fictional character looks like.

My entire staff goes to galleries to look at recent shows. We talk about the photography art world. In the section "Goings on About Town," we always pull an image out of the photography listings. I am very happy working at this magazine, and I have a wonderful editor who is open to ideas and has a good eye. Not all editors have that ability. They may be good editors, but they just do not have the ability to see visually—and that is when you have a problem.

We try to use a mix of black & white and color photographs. Black & white used to be more popular because it appeared nostalgic and looked arty. At this time, often black & white seems old fashioned. Presently, I like what is going on with color, especially the electronic color. There is sort of a black & white characteristic in the new color; it is almost monochromatic, which can be so beautiful at times. There is a broader range of photographic processes that we have now.

What is the best way for the photographer to show you their work?

We do not have time to meet with the photographer when we look at their portfolio, so I cannot ask them questions about their work. What I look for is the visual handwriting. It is not important what is being photographed, but rather how the photographers see. I look for consistency in the work. Is there something that I see that is special in the way the photographer looks at things? If I do not see anything, then I am not interested. Other editors may do it differently, but I am looking for something special. We are all looking for a new way to see something, and we are always looking to discover someone—that is the fun part.

We do not have any idea of the age of the photographer. However, if the portfolio is from a twenty-five year old, it might be slightly flawed, but you expect over time he or she will grow and become more professional. A forty-five year old will have more technical experience and it will show in the work. It is not a fair system, but that is the reality. We do look for interesting work and keep work on file. We do not use a lot of photography, so it might take a long time before we call. We have staff photographers, but we rotate and use the "Goings on About Town" section and the back pages of the mag-

azine to try out new photographers. Those photographs are smaller and can be redone if they do not work. The photographers only have one chance to create an image that works; if it does not work, we will not publish it. We take calculated risks.

In a portfolio, less is more. Photographers should be able to make their point in about fifteen images. Rigorous editing is important, as is a clean presentation. The photographer should trust their instinct and know what they want to do and only vary their work from magazine to magazine. For this magazine, I want to see the photographer's personal work. The personal work enhances the commercial work.

The associate picture editor first reviews portfolios, and if there is anything of interest in them we look at the work and discuss whether we should bring the person in. I get a lot of visual e-mails, which are annoying, but I feel I need to look at them. We get a lot of portfolios every Monday—about ten portfolios.

The personality of the photographer is also important. For instance, if we assign a photographer to photograph a philosopher, they tend to be a pretty serious person; it will be different if the subject is a video artist. There is a big connection between the personalities, and the images, and the way they are produced. I always ask the writer, "What

kind of person are we photographing?" If they say they are shy, I may choose a photographer who is more outgoing to bring them out. It is an additional element to think about when choosing a photographer. There is an exchange in portrait photography and it must be considered.

Do you like to take photographs?
I like to take snapshots but I cannot take a good picture. Perhaps it is because I have seen too many good ones. I am not a technical person and I have no interest in it. I look at a lot of the hip fashion magazines, but we are more "classic" in our approach. It is important to look at it whether I get it or not.

▼ GEORGE PITTS: DIRECTOR OF PHOTOGRAPHY (VIBE)

George Pitts is a painter, photographer, writer, and the director of photography at Vibe *magazine. His paintings, drawings, and photographs have been shown in numerous exhibits. Pitts' writing and art have appeared in* The Partisan Review, The Paris Review, Big Magazine, One World, Vibe, aRude *and* Juxtapose. *His photographs have been published in the* New York Times Magazine, Spin, Premiere, Talk, Manhattan File, *and* Gotham, *among others. As director of photography he has received a number of highly prestigious honors in the field of photography. Pitts also makes time in his demanding schedule to teach a course called "The History of Sexuality in Photography" at the Parsons School of Design and the School of Visual Arts.*

Steven Begleiter: What were the major influences that led you into your career as a director of photography?
George Pitts: MOMA Photography Curator Susan Kismaric suggested that I consider the field. She had had experience as a picture editor, and thought I could do it too. Other influences are more cultural/artistic in nature. I work as a photography edi-

tor in the music field, and there my influences include: Roxy Music (including their stellar and sexy album art), Grace Jones (the futuristic/ultra-stylish image of the black female artist), Miles Davis, Sly and The Family Stone, and David Bowie.

I also grew up with *Life* magazine, and was casually but deeply influenced by its large-format design and humanistic imagery. As a child my

mom also read *Vogue, Ebony,* and *Jet* regularly and those magazines had their inevitable effect on my taste.

Finally, I have been a painter, writer, and photographer for a long, long time. Through those activities I have absorbed untold bodies of imagery ranging from Vermeer to Balthus, Man Ray, Eugene Smith, and James Van Der Zee—on through to Guy Bourdin and Helmut Newton.

What influences do you feel contributed most to your photographic aesthetics?

Art photography, surrealist erotic imagery (Bellmer, Molinier); American art photography (Walker Evans, Diane Arbus); avant-garde fashion photography; photojournalism and documentary work (August Sander, Gordon Parks and his work with *Life*); postmodern art, fashion, and nude photography (which entail the influences of the civil rights movement, feminism, gay liberation, punk, and beyond).

What do you feel is/are the major role(s) of the photo editor/art director?

Discerning, unerring taste for beauty, realism, subtlety, and surprise play a major role. Also helpful are a verbal ability to explain visual innovation and quality, and a passionate enthusiasm for photography.

What do you feel is the current direction of portrait photography?

Portrait photography is moving toward staged and authentic realism. Right now there is too much deadpan, humorless realism that is staged largely in interior environments and distinguished largely by its use of irony or extreme sharpness. I'd like to see a deeper pursuit of well-crafted, risk-taking, yet compassionate portraiture.

What are the main elements you look for in a photographer's portfolio?

A singular affecting vision, good craft, a facility for lighting in various contexts, a passion for some matter of content, theme, style, or idea.

Do you enjoy taking photos yourself and, if so, what kinds of things do you like to photograph?

I enjoy photographing women of all ages, including portraits, nudes, and fashion nudes, above all in the genre of art photography. I also enjoy shooting as seriously as I can, and as well as I can, anything pertaining to the human condition.

▼ SUSAN WHITE: PHOTOGRAPHY DIRECTOR (VANITY FAIR)

Susan White joined Vogue *under the mythic fashion editor Polly Mellen and moved to* Vanity Fair *in 1988. At* Vanity Fair *she oversees all of the memorable images that go into the magazine's pages and works closely with the world's most celebrated photographers.*

Steven Begleiter: What were the major influences that led you into your career as a director of photography?

Susan White: Probably the fact that I didn't have enough talent to be a painter. And I was lucky that my first job in this field was with a wonderful photographer named James Moore.

What influences contributed most to your photographic aesthetics?

Coming of age at a time when the print media became more prominent in our culture had to have had an affect on my aesthetics. I can't say it was one thing or one person. It was the world around me. I think that's what influences all of our aesthetics.

What do you feel is the major role of the photo director?

To support and guide photographers without constraining their creativity and vision, and to inspire them (if we can).

What do you feel is the current direction of portrait photography?

Unfortunately, I feel that so much in our creative culture is repetitive, not just derivative. It's beyond simply being influenced. Images are often direct rip-offs of movie stills, historic images, that sort of thing. I'm hoping we collectively move away from that soon. I do think that the pure photograph is becoming a rarity (by *pure*, I mean from shot to process to print). Most images we now see have been

enhanced or retouched in some way on a computer. It's gotten to the point that it's almost impossible to show a photo that hasn't been digitally retouched—at least slightly. They often don't look quite as polished. It's as if all of our eyes have gotten used to that enhancement. It's a sad fact, really.

What are the main elements you look for in a photographer's portfolio?

I like to see that they have mastered the technology a bit. I respect that, as well as some element of artful control. A photographer's style can peek through despite the circumstance they're shooting in—look at Salgado.

I do think presentation is important. A well cared for portfolio says something, and a little editing and art direction goes a long way. It's a problem for me if there are too many photos, or if the portfolio itself is unwieldy (too large, difficult to open, etc.).

Do you enjoy taking photographs yourself and, if so, what kinds of things do you like to photograph?

I am not a photographer, but like everyone else in the world, I love taking snapshots of my family and friends (preferably in natural light with a point and shoot).

*T*HE FOLLOWING IMAGES ARE A COLLECTION OF SOME OF MY favorite portraits that I have taken over the years. These are the portraits that, for one reason or another, keep surfacing to the top of my files. Some are spontaneous and taken by intuition, others are carefully planned and meticulously directed. Some were done on assignment, others are from personal projects.

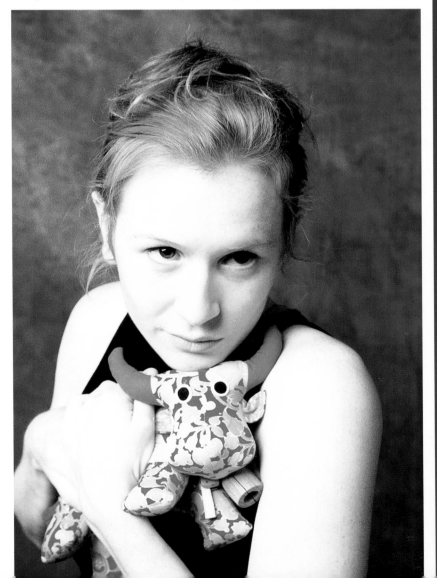

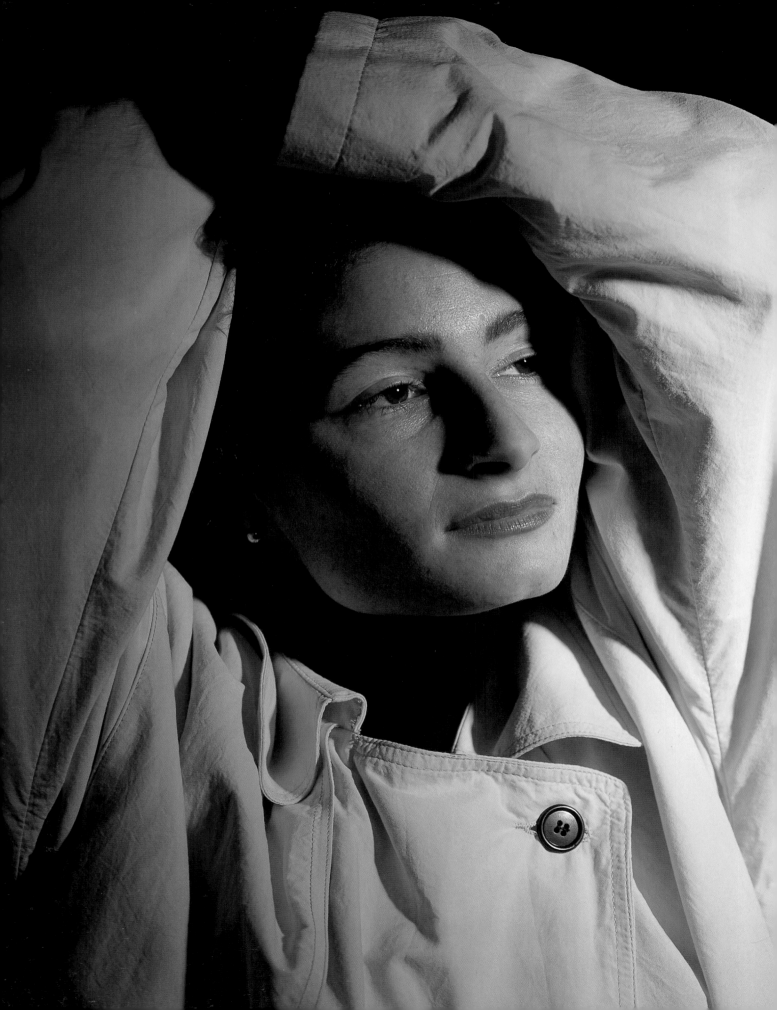

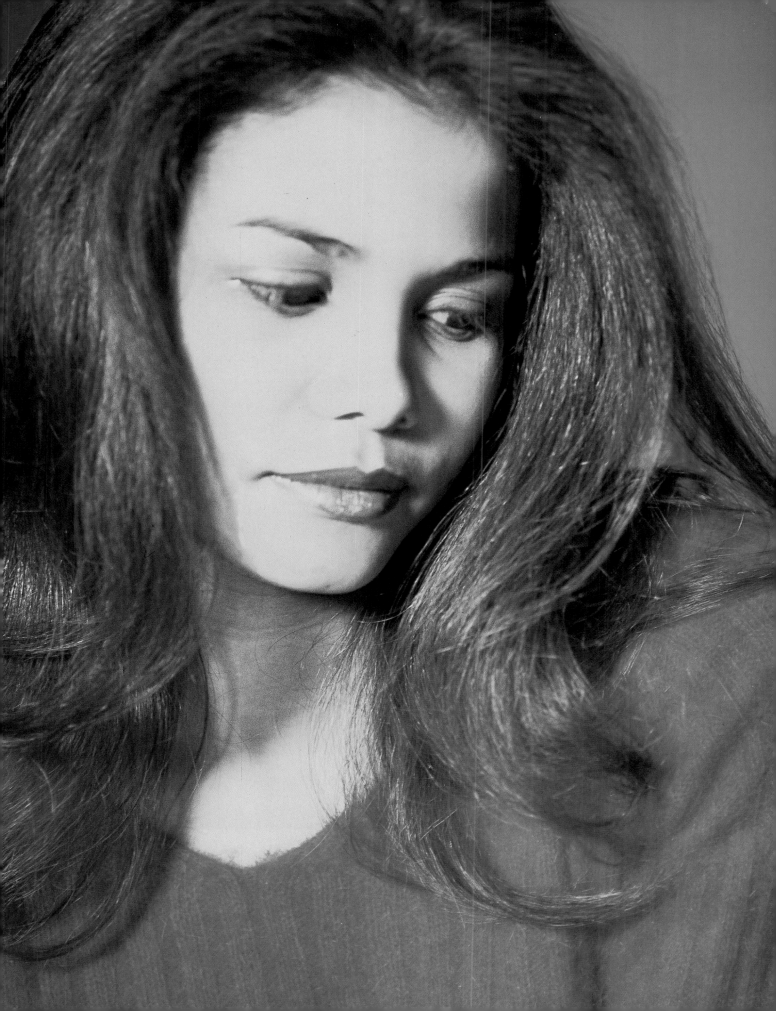

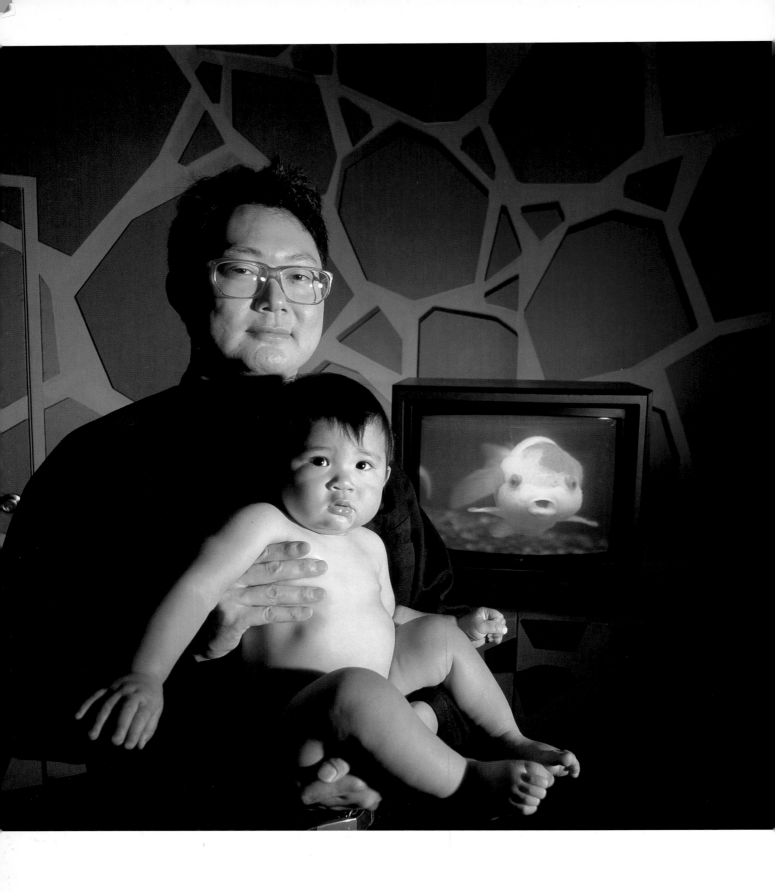

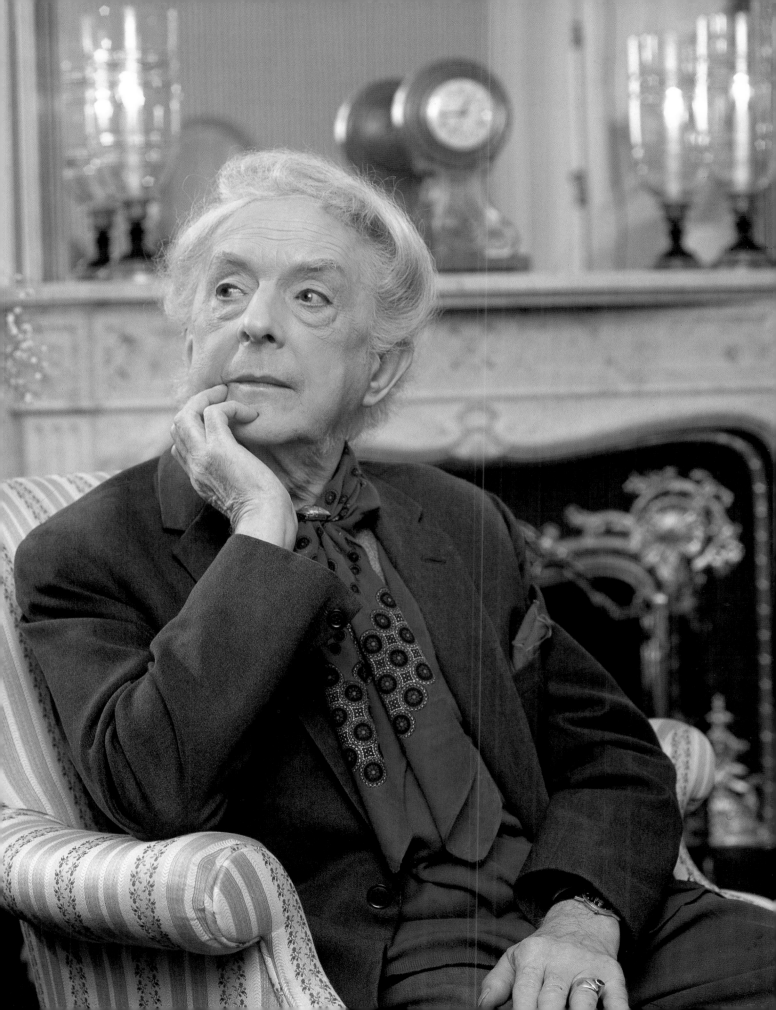

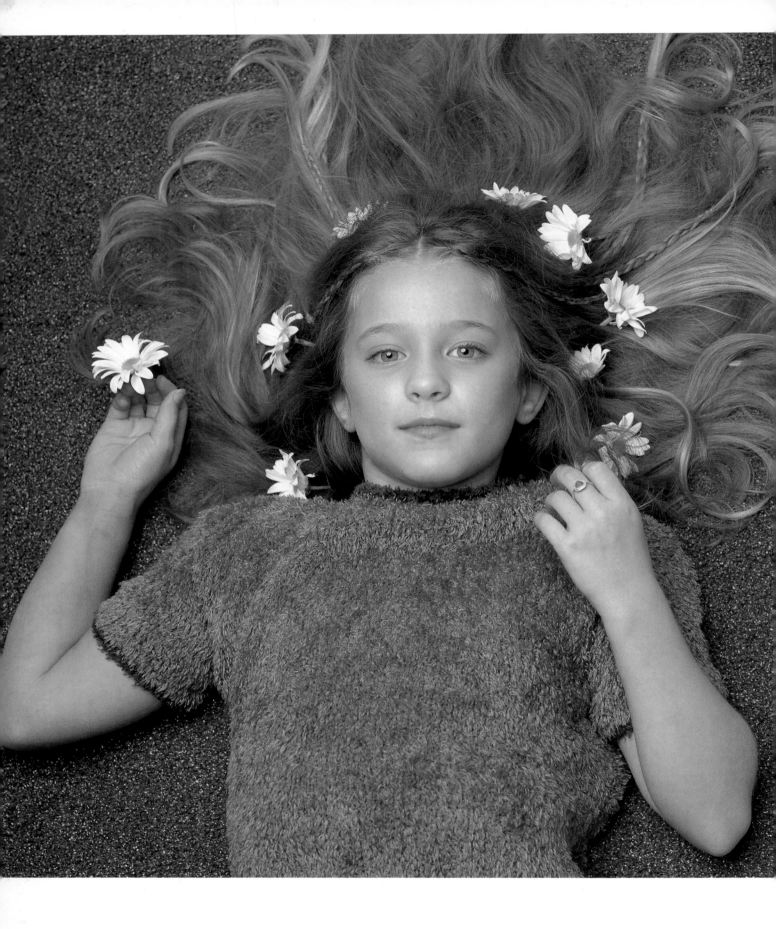

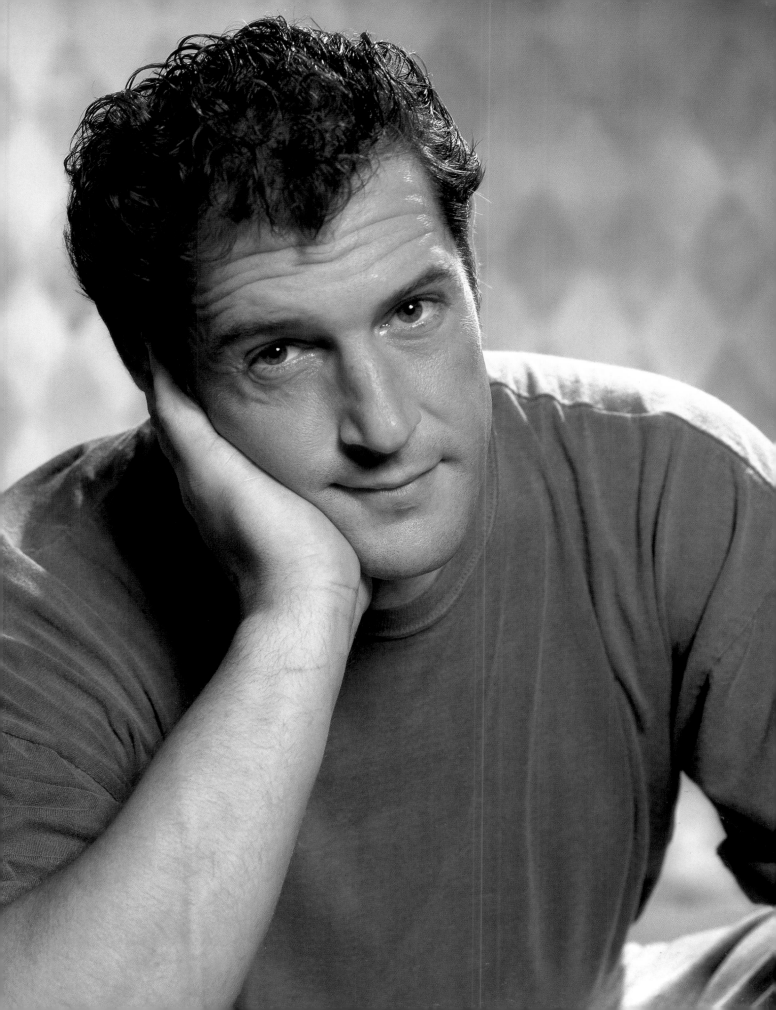

16. FINAL THOUGHTS

*T*HROUGH MY YEARS AS A PROFESSIONAL PHOTOGRAPHER I HAVE found portraiture to be endlessly fascinating. In writing this book I wanted to create, not a step-by-step set of instructions, but a guide for the reader to discover their own style and explore the many possibilities within portrait photography. There are both artistic and practical aspects to embarking on a career in portraiture; each photographer must create their own path.

It is a privilege to make my living creating portraits. I have met and gotten to know fascinating people, experienced break-through creative moments, and learned about many of life's lessons I may have otherwise missed. It has been, and will continue to be, an ever-changing adventure. I wish you all the best in your journey.

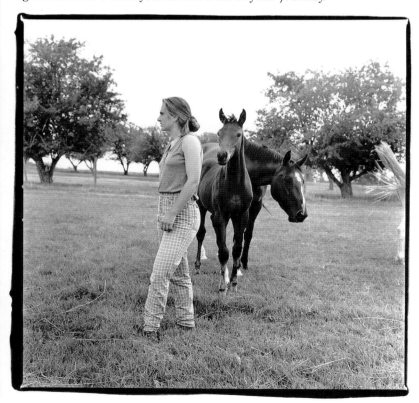

APPENDICES

▶ **APPENDIX A—MODEL RELEASES**

Ask your subjects to sign a model release. This gives you permission to publish the image in different venues without the fear of being sued. This can be a sensitive matter and it is important that you are up front with your subject about signing the model release. Explain to them why you want them to sign the release and what other usages you may have in mind. On page 120, you'll find sample of an adult model release. A different model release is required for minors and must be signed by their guardian. A sample of this release is found on page 121.

Photographer Name: _____

Address: _____

Phone Number: _____

Adult Model Release for Photography

I, _____ having received valuable consideration, hereby grant to _____ , Photographer, Photographer's representatives, publishers, agents, heirs and assigns, the irrevocable and unrestricted permission to make photograph(s) and/or composite illustration(s) of myself or in which I may be included, or property under my control. I agree that my right to privacy has not been violated.

I understand the material created may used commercially, and may be published for the general public to view. Unless otherwise restricted below, I hereby grant the irrevocable permission to use, reuse, publish, republish display, project, alter without restriction, or otherwise use images of me or wherein I may be included, in any manner, in any medium, now or hereafter known, without restriction.

I understand that ownership of and copyright to, the created image(s), photograph(s) and/or composite illustration(s) is the exclusive and private property of the Photographer and all rights are reserved and that I have no ownership interest in the produced material and no right to use thereof unless specifically agreed to below.

Unless otherwise stipulated below, I understand I do not have the right to inspect or approve the finished product or products and/or the advertising layout, copy or other material that may be used in conjunction with the photograph(s), or the use to which it may be applied.

I hereby release, discharge and agree to hold harmless, Photographer, Photographer's employees, agents, heirs or assigns, from any liability or for any damages which I may sustain from the use of the photographic material produced, including any blurring, distortion, alteration, optical illusion, or use in composite form, whether intentional or otherwise that may occur or be produced in the taking of said picture or in any subsequent processing thereof, as well as any publication thereof, including without limitation any claims for libel or invasion of privacy.

Unless otherwise stipulated below, I agree I have been reasonably compensated for the use of my likeness and may not seek additional compensation for the use or reuse of the created images, photograph(s) and/or composite illustration(s).

I hereby warrant that I am of legal age and have the right to contract in my own name. I have read the above authorization, release and agreement prior to its execution and I am fully familiar with the contents thereof. This document shall be biding on my heirs, representatives, and assigns.

Additional Terms:

Date: _____ Model: _____

Date: _____ Witness: _____

Photographer Name: _____

Address: _____

Phone Number: _____

Minor Release for Photography

Minor Model: _____ Birth date: _____

In regard to the engagement as a model of the minor named above and for valuable consideration herein acknowledged as received, and unless otherwise restricted below or by separate written agreement, I hereby grant to _____, Photographer, Photographer's representatives, publishers, assigns and heirs, those for whom Photographer is acting and those acting with Photographer's authority and permission the absolute, irrevocable and unrestricted right and permission to copyright, create, use, reuse, publish and republish photograph(s), photographic portrait(s) or picture(s) of the minor or in which the minor may be included, in whole or in part. I further grant the right without restriction to Photographer to make changes or alterations to the material produced, and to include use of the minor's own or fictitious name or reproductions thereof. I consent to the unrestricted use made through any medium, and in any and all media now or hereafter known, for any other purpose whatsoever.

I understand that unless otherwise stipulated below, I or the minor may not inspect or approve the finished product or products or the advertising copy or other material that may be used in connection with the photographic material or the use to which it may be applied.

I hereby release, discharge and agree to hold harmless Photographer, Photographer's representatives, publishers, assigns, heirs, and all persons acting under Photographer's permission and/or authority or those for whom Photographer is acting from any liability and/or damages which I or the minor may sustain from the use of the photographic material produced including any blurring, distortion, alteration, optical illusion or use in composite form, whether intentional or otherwise that may occur or be produced in the taking of said picture or in any subsequent processing thereof, as well as any publication thereof, including without limitation any claims for libel or invasion of privacy.

Unless otherwise stipulated below, I agree I have been reasonably compensated for the use of my likeness and may not seek additional compensation for the use or reuse of the created images, photograph(s) and/or composite illustration(s).

I hereby warrant that I am of full legal age and have every right to contract for the minor in the above-mentioned regards. I state further that I have read the above authorization, release and agreement, prior to its execution and that I am fully familiar with contents thereof. This release shall be biding upon the minor, myself, my heirs, representatives, and assigns.

Additional Terms:

Date: _____ Legal Guardian: _____

Date: _____ Witness: _____

▶ **APPENDIX B—INVOICING YOUR CLIENT**

There are some good business management and financial software programs, such as Intuit's QuickBooks®, Photo One®, and Fotoquote 4.0® that will assist you in balancing your books and invoicing your clients. If you are just beginning your business, it is a good idea to hire an accountant familiar with small business services to set up your accounts.

When you are creating your invoice for the client it is important to break down the numbers. The following is an example of how an invoice may look. Print two copies of the invoice, one for the client and one for your records. Be sure to write down the terms of when the payment is due and follow up with a friendly call to client if the invoice is past due. The longer you wait to collect, the more difficult it will be collect your payment. Another strategy is to ask for part of the payment (an advance) before the shoot to cover your expenses. This is especially important on big production shoots, where you may have to lay out a lot of money up front for props, airline tickets, etc. Remember, you are not a bank it is not your responsibility to loan client money for over thirty days without collecting interest.

INVOICE

BILL TO:
XYZ Photography
1111 Main Street
Anytown, NY 11111-1111
Attention: Accounts Payable

Date	Invoice #
9/25/04	1503

PO NO.	TERMS	PROJECT
#0137	Due on receipt	

QUANTITY	DESCRIPTION	RATE	AMOUNT
	Job Description: Color photographs of John Doe of the Aardvark Corporation at the Yosemite Love Park on September 25, 2004 for the Aardvark Corporation 2004 annual report.		
	Rights and Usage: For the Aardvark 2004 annual report.		
1	Day(s) of creative service	$2500.00	$2500.00T
1	Assistant(s) fees	200.00	200.00T
14	120 Film and processing	35.00	490.00T
2	Polacolor type 669/665	20.00	40.00T
3	Hi-res scan of selected images	35.00	105.00T
1	Makeup artist	500.00	500.00T
	Food for staff and clients	50.00	50.00
	SUBTOTAL of TAXABLE ITEMS:		3885.00
2	Messengers	15.00	30.00
1	Federal Express	20.00	20.00
	Out-of-state sale, exempt from sales tax	0.00%	0.00

Thank You for Your Business!

Total:	$3935.00

Albumen prints—In 1847, Abel Niépce combined a mixture of egg whites and potassium iodide. He then put a coating of the mixture on glass and immersed it in a bath of silver nitrate to produce a light-sensitive surface. In 1850, Blanquart-Evrard coated paper in the same way, enabling albumen prints to be made from collodion negatives.

Analog-to-digital converter (ADC)—A device that converts an analog signal into a digital signal. Via this device, complex waveforms are converted into simple strings of numbers.

Angle of view—The area of a scene that a lens covers or sees. The angle of view is determined by the focal length of the lens. A wide-angle lens includes more of the scene than a normal or telephoto lens.

Aperture—The opening of the lens through which light passes to expose the film. The size of aperture is either fixed or adjustable. Aperture size is usually calibrated in F-numbers; the larger the number, the smaller the lens opening. The aperture affects the depth of field—the smaller the aperture, the greater the area of sharpness; the bigger the aperture, the less the area of sharpness.

Artifacts—Telltale grid-like pattern· (or other distortion) in the pixels that results from digital compression.

Background light—A light used to illuminate the background of the portrait.

Back lighting—Lighting setup in which a light source is behind the subject and pointed toward the camera. Effective for creating separation between your subject and a dark background.

Baffle—Fabric placed between the flash and the front of the softbox to diffuse the light.

Barndoor—A device attached to the front of the light head that has two or more black flaps (panels) that help shape the light. They are also useful in goboing the light from the camera lens.

Bit—Smallest unit of digital memory; a contraction from "binary" and "digit."

Boom Stand—Adjustable arm mounted at an angle from a vertical stand and often counter-balanced by a weight.

Bracketing—Intentionally over- and underexposing your film by closing down and opening up in one-stop increments on the aperture or shutter from the metered light reading to assure yourself of a good exposure.

Carbon process—A chemical process, using carbon, perfected in 1864 to prevent fading of prints.

Charge-Coupled Device (CCD)—A light-sensitive chip used for image gathering. The CCD is an analog sensor; the digitizing happens when the electrons are passed through the analog-to-digital converter (ADC). This changes the analog signal to a digital file or signal.

Complementary Metal Oxide Semiconductor (CMOS)—A light-sensitive chip similar to a CCD. CMOS chips use two negative and positive polarity circuits. Because only one of the circuits can be on at once, CMOS chips are less energy consuming than other chips that utilize simply one type of transistor. The CMOS sensor has a clear advantage over the standard CCDs.

Contrast—The exposure difference between the light and dark areas of an image. Also the brightness range of a subject or the scene lighting.

Data compression—Digital cameras don't have the massive amounts of storage a computer does, yet they create files that can be quite large. Because of this, the camera compresses the data so more images can be stored in less memory. The less compression you use, the better your image quality will be; the more compression used, the more images can be stored.

Depth of Field—The distance between the nearest and farthest objects that appear in acceptably sharp focus in a photograph. Depth of field depends on the lens opening, the focal length of the lens, and the distance from the lens to the subject.

Digital back—A removable device that replaces the film back in medium and large format cameras, and the 35mm film body.

Digital noise—Stray pixels in an image that look like film grain.

18% gray—Also known as middle gray and Zone 5. Reflective light meters evaluate a scene and provide a reading designed to average the tones in it to an 18% gray value. This can be misleading if the metered area is predominately white or black.

Exposure Value—The range of light levels within which equipment operates. For example, a manufacturer may describe a light meter as having a EV –1 to EV 20 (4 seconds at f1.4 to $^1/_{2000}$ second at f22 using a film with an ISO of 100).

Fill-in flash—Additional lighting from a flash used outdoors to compensate for underexposed areas of the portrait.

Fill light—A secondary light used to soften the shadows created by the main light. It is also used to reduce the lighting ratio of a portrait.

FireWire—A very fast way to attach peripherals to a computers. FireWire uses an external bus that supports data transfer rates of up to 400 Mbps. Firewire was developed by Apple and falls under the IEEE 1394 standard. Other companies follow the IEEE 1394, but have names such as Lynx and I-Link. Confirm that your operating system can support the FireWire before purchasing devices that use this interface system.

Flatbed scanner—A digitizing device in which the original image remains stationary while the sensors (usually a CCD linear array) pass over or under it. The scanned material is held flat and scanned using a reflective process.

Flat lighting—Lighting that produces very little contrast or modeling on the subject, plus a minimum of shadows.

Focal length—The distance between the film and the optical center of the lens when the lens is focused at infinity. The focal length of the lens, on most adjustable cameras, is marked in millimeters on the lens mount.

Gobo—A dark card or piece of fabric that is placed between the light source and the subject to block unwanted light spill. A gobo can also be used to prevent lens flare by placing it between the light source and the camera lens.

Grid—Grids in a honey combed design placed in front of the light source to narrow the beam of light; the larger the degree, the broader the light.

Hair light—A light that comes from behind the subject to illuminate the hair and separate it from the background.

Hard light—High contrast lighting.

Highlight—A very bright area of a scene, print, or transparency. Appears as a dense area on a negative.

Hot lights—A common term for continuous light sources, such as tungsten and HMI units.

Incident meter—A light sensor that measures the amount of light falling on the subject. The sensor (light meter) is pointed toward the light source or camera for an accurate reading.

Interpolated resolution—A sampling technique used to increase the size of an image file by creating more pixels and increasing the apparent resolution of an image. Interpolation examines the existing pixel information and creates additional pixels by averaging the existing values.

JPEG (or JPG)—The most common type of compressed image file format

used in digital cameras. This is a "lossy" type of storage because even in its highest quality mode, there is compression used to minimize the file size.

Kick light (a.k.a. kicker)—A light placed at a low angle to the side or behind the subject to add a rim light effect or accent on the subject.

Latitude—Degree by which exposure can be varied and still produce an acceptable image. The degree of latitude varies by film type. Faster films tend to have greater latitude than slower films.

Lens flare—Reduced contrast as a result of non-image-forming light entering the lens or being reflected by the camera interior.

Lighting ratio—The difference in exposure between the highlight and shadow side of the face expressed as a ratio (such as 2:1). The higher (or longer) the lighting ratio, the greater the contrast.

Liquid crystal display (LCD)—Type of screen found on many digital cameras that allows previewing or reviewing of images. Also serves as a monitor for the interface of some camera controls.

Liquid crystal display (LCD) monitor—LCD monitors are thin panel displays. They create images with tiny backlights that project light through glass sheets, polarizing filters, and tiny electronic switches, plus a transparent liquid-crystal layer.

Loop Lighting—A type of lighting setup that broadens faces and reduces the appearance of ruddy skin.

Main light—The principal source of light, also know as the key light. This light establishes the character of the overall lighting.

Medium format camera—Any camera that accepts 120/220 film sizes. The sizes are 6x4.5cm; 6x6cm; 6x7cm; 6x8cm; and 6x9cm.

Megapixel—A CCD resolution of one million pixels. Digital cameras are commonly rated by megapixels. You multiply the horizontal resolution by the vertical resolution to get the total pixel count (1280 x 960 pixels = 1 Megapixel; 1600 x 1200 pixels = 2 Megapixels; 2048 x 1536 pixels = 3 Megapixels, etc.).

Memory card—Small storage devices that can be inserted into a digital camera to hold images. When the card is full, it can be removed and another card inserted. The image can later be downloaded from the card, making the card ready to be reused.

Open shade—Describes the lighting found in places such as the shade of a tree or building. Open shade is desirable in portrait photography due to its low contrast and minimal shadows.

Optical resolution—The maximum physical resolution of a device without software interpolation.

Parabolic reflector—A reflector designed to align light rays generally parallel to the axis formed by the point source and the center of the reflector, eventually resulting in a cylindrical-to-wide beam that is very effective for beauty lighting.

Parallax—In twin-lens-reflex cameras and rangefinder cameras, the difference between what the viewfinder sees and what the camera records caused by the separation between the viewfinder and the picture-taking lens. There is no parallax with single-lens-reflex cameras.

Paramount lighting—A type of lighting setup that will flatten features, reduce textures, and broaden the look of a narrow face.

Pixel—Single point in a digital image. The number of bits used to represent each pixel determines how many colors or shades of gray can be displayed. For example, in an 8-bit color mode, the color monitor uses 8 bits for each pixel, making it possible to display 2^8 (256) different colors or shades of gray.

Rangefinder camera—A camera that measure distances from a given point, usually based on slightly separated views of the scene provided by mirrors or prisms.

RAW data—RAW files are unprocessed data—at 12 bits per channel—from a digital camera's imaging chip. Lossless compression is applied to reduce file size slightly without compromising any quality.

Reflected-light meter—A light meter that uses a sensor to measure the amount of illumination reflecting off surfaces. Internal meters in cameras, some handheld meters, and spot meters utilize this system.

Reflector—A metal, glass, or fabric apparatus used to redirect light onto the shadow of the subject.

Rembrandt Lighting—A type of lighting setup that works well for full faces and emphasizes texture.

Rule of thirds—Compositional guideline that divides the image area into thirds, horizontally and vertically. The intersection of any two lines is a dynamic point where the subject should be placed for the most visual impact.

Shadow—A dark area of a scene, print, or transparency. Appears as a thin area on the negative.

Scheimpflug effect—Allows you to increase effective depth of field simply by tilting the camera lens along its axis in the direction of the image plane. This technique of sharpness distribution control—normally only possible with the swing and tilt movements of a view camera—allows you to align the lens with any subject plane, without changing the camera position or stopping down the lens.

Single-lens reflex camera (a.k.a. SLR)—Any camera that allows you to see through the camera's lens as you look in the viewfinder. Most SLRs have internal light metering and flash control that function through the lens.

Slave unit—A light sensor that triggers auxiliary flash units almost simultaneously with the primary flash. Some strobe packs have slaves built into the system.

Small format camera—Any camera that accepts 35mm film or smaller.

Snoot—A tube that is placed in front of the light to project a circle of light on a subject or background. The concentration of light also reduces light spill.

Softbox—A light controlling apparatus that fits over the light head and diffuses the light source. Softboxes come in all shapes and sizes and are primarily used when you want to simulate window light and have a more defined edge on your portrait.

Specular light—Illumination that produces hard-edged, sharply defined shadows. This light is often used for dramatic effect. (See hard light.)

Split lighting—Type of lighting that narrows the face and brings out textures.

Strobe light (a.k.a. flash)—A strobe light stores up energy in an electrical component called a capacitor, then dumps it all into a lamp bulb filled with xenon gas. The insulating gas in the bulb conducts electricity. The result is a brief and intense flash of light.

Stroboscope—Fast charging flash for the camera.

Super clamp—A multipurpose clamp that allows you to lock in a strobe head and clamp it to a horizontal pipe or bar. Very useful when light stands cannot be used.

Synchronization, flash—A method of matching the duration of the flash light with the maximum shutter speed to ensure correct exposure of the entire frame.

TIFF (Tagged Image File)—An uncompressed image file format that is lossless and produces no artifacts (as is com-

mon with other image formats, such as JPG).

Translucent powder—Powder used to reduce shine on a person's face caused by the light reflecting off the skin oil.

Umbrella—Diffuses and broadens light. The umbrella creates a wraparound light on your subject. Umbrellas come in different sizes and are either soft white, flat white, silver, or zebra (mix of white and silver).

USB (universal serial bus)—A simplified way to attach peripherals and have them recognized by the computer. USB ports are about ten times faster than a typical serial connection. USB ports are usually located in easy-to-access locations on the computer or keyboard.

White balance—Means by which a digital camera adjusts colors based on a reading of the lightest so that they appear correct in the final photograph.

Wide-angle lens—A lens with a wide field of view and a short focal length. On a 35mm camera, any lens with a focal length shorter than 35mm would be considered a wide-angle lens.

Xenon gas—The gas used in some arc lamps and strobe heads, that allows for an extremely high luminous intensity and a color temperature of approximately 6200° Kelvin.

▶ APPENDIX D—ORGANIZATIONS

Ironically, being a professional portrait photographer can be very isolating. Unless you are working in a studio with many employees or actually shooting a portrait, most of your time will be spent "doing the business of photography"— and doing it alone. Unlike other professions there are no "real" unions to watch over your livelihood. There are, however, some great photographic organizations you should get involved with—both for the social aspects and to gain valuable insight into the career you have chosen. The following is a partial list of organizations to consider.

American Society of Media Photographers (ASMP)
www.asmp.org

Advertising Photographers of America (APA)
www.apanational.org

Society for Photographic Education (SPE)
www.spenational.org

Photo Marketing Associations International (PMAI)
www.pmai.org

Professional Photographers of America Inc. (PPA)
www.ppa.com

Wedding and Portrait Photographers International (WPPI)
www.wppinow.com

American Society of Picture Professionals
www.aspp.com

Photographic Society of America
www.psa-photo.org

▶ APPENDIX E: BIBLIOGRAPHY AND RESOURCES

Allen, J. J. *Posing and Lighting Techniques for Studio Portrait Photography.* Amherst Media, 2000.

Brystan, Lori. *High Impact Portrait Photography: Creative Techniques for Dramatic, Fashion-Inspired Portraits.* Amherst Media, 2002.

Finn, David. *How to Look at Photographs: Reflections on the Art of Seeing.* Harry N. Abrams, Inc., 1984.

Frank, Robert. *The Americans.* Pantheon Books, 1958.

Graves, Carson. *The Zone System for 35mm Photographers: A Basic Guide to Exposure Control.* Focal Press, 1997.

Halsman, Yvonne and Philippe Halsman. *Halsman at Work.* Harry N. Abrams, Inc., 1989.

Harris, Mark Edward. *Faces of the Twentieth Century: Master Photographers and Their Work.* Abbeville Press, 1998.

Hurter, Bill. *The Best of Portrait Photography: Techniques and Images from the Pros.* Amherst Media, 2003.

Hurter, Bill. *Portrait Photographer's Handbook.* Amherst Media, 2001.

Johnson, Chris. *The Practical Zone System, 3rd. Ed.* Focal Press, 1998.

Kelby, Scott. *The Photoshop Book for Digital Photographers.* New Riders Publishing, 2003.

Lav, Brian. *Zone System: Step-by-Step Guide for Photographers.* Amherst Media, 2000.

Lowell, Ross. *Matters of Light & Depth.* Broad Street Books, 1992.

Monizambert, Dave. *Professional Digital Photography: Techniques for Lighting, Shooting, and Image Editing.* Amherst Media, 2002.

Newman, Arnold. *One Mind's Eye: The Portraits and Other Photographs of Arnold Newman.* David R. Godine, Publisher, 1994.

Newhall, Beaumont. *The History of Photography: From 1839 to the Present Day.* The Museum of Modern Art, 1964.

Oppenheim, Selina. *Portfolios that Sell: Techniques for Presenting and Marketing Your Photographs.* Amphoto, 2003.

Perkins, Michelle. *Beginner's Guide to Adobe Photoshop, 2nd Ed.* Amherst Media, 2003

Perkins, Michelle. and Paul Grant. *Traditional Photographic Effects with Adobe Photoshop, 2nd Ed.* Amherst Media, 2003

Shamen, Harvey. *The View Camera.* Amphoto, 1991.

Simmons, Steve. *Using the View Camera.* Amphoto, 1993.

Smith, Jeff. *Corrective Lighting and Posing Techniques for Portrait Photographers.* Amherst Media, 2000.

Smith, Jeff. *Outdoor and Location Portrait Photography, 2nd Ed.* Amherst Media, 2002.

Smith, Jeff. *Professional Digital Portrait Photography, 2nd Ed.* Amherst Media, 2003.

Strobel, Leslie D. *Camera Technique, 7th Ed.* Focal Press, 1999.

Wacker, J.D. *Master Posing Guide for Portrait Photographers.* Amherst Media, 2001.

Weaver, Mike. *Julia Margaret Cameron (1815-1879).* Little, Brown and Company, 1984.

INDEX